Καλειδoscope

HANS SILVESTER

Καλειδoscope:

COLOURS

AND

TEXTURES

OF THE

GREEK

ISLANDS

Introduction by Hubert Comte

WITH 110 COLOUR ILLUSTRATIONS

THAMES AND HUDSON

Translated from the French *Les Couleurs du Temps* by Jane Brenton

The photographs for this volume were taken using Leica M6 and R6 cameras,
Leica 35mm to 180mm lenses and Kodak films, 64 and 200.

First published in Great Britain in 1997
by Thames and Hudson Ltd, London

British Library Cataloguing-in-Publication Data

A catalogue record for this book is available from the British Library

ISBN 0-500-01776-X

Printed and bound in Italy

Photographing cats behaving naturally requires patience, enormous patience. You have to learn the art of waiting. Yet waiting is no hardship if at the same time you know how to observe, examine and explore what lies in front of you. When I was in the Greek Islands, that was how I found the necessary patience and perseverance to take the photographs for my books *Cats of the Greek Islands* and *More Cats of the Greek Islands*.

In the six years I devoted to cats, I always had an eye for the visual beauty that could be discovered in the smallest of details. Since the time photography began, there have, of course, been innumerable photographers who have concentrated on details and hordes of enthusiasts who have used close-ups to create an impact. I have invented nothing new. I simply want to show what is there to be seen if you keep your eyes open and also possess a certain visual sensitivity. For what we are really talking about here is cultivating the art of observation.

My photos show things fashioned by man, in wood, iron or stone, and transformed continuously over time. Through the years, the materials are weathered by sun, wind and rain. All objects are subject to this form of entropy, from the moment they are created to their eventual disappearance. All objects are both one and many things, because time gives them new colours, which in turn are destined to vanish. Man, however, has the power to intervene, to make any object he chooses immediate and vivid.

My intervention in the world of objects is limited, but crucial. By my choice of subject matter, the way I decide to frame my images, the quality of light I strive to capture and, ultimately, through the associations suggested by the photos I select, I create an ensemble. I have never in any way sought to modify the objects themselves, but in combining them I have created an intimate gallery of the imagination, personal in inspiration but presented now to a wider audience.

All these photos were taken on the islands of the Cyclades, famous for their white villages and flat-roofed houses with blue shutters. The fact that today so many of the buildings have their doors and windows boarded up is a reminder of the time, not so long ago, when the poorest of the inhabitants left

this paradise of the senses to seek a better life in the United States or Australia. Many have never returned, and without maintenance the houses are slowly decaying, subject to a climate of extremes, hot in summer and wet in winter.

Blue is the Greeks' favourite colour. There is a virtually limitless range of different blues. Then, too, there is the time factor, the ways the pigments alter. The materials become warped, cracks appear, the actual substance of the paintwork changes visibly; successive coats of paint react in different ways; and by this means, a flat, faded surface is transformed into an interesting composition.

Chance leads me to the spot: a particular composition catches my eye, I see my 'painting' and I photograph it. There are times when such discoveries represent for me moments of pure happiness. Why does one composition or group of objects spark my curiosity while another leaves me cold? Presumably it has to do with my cultural references, all those many works of art stored in my memory. There are certain painters who have particularly influenced me, among them Paul Klee and Nicolas de Staël, to mention only two. Long before I ever did, painters such as these observed details similar to those in my photographs and incorporated them into their paintings.

I am one of the many who have benefited immensely from visiting museums and galleries. The paintings I have seen have contributed to developing and enriching my visual sense and taught me both to see more and to see better.

Not one of the photos in this book is an abstract composition; all are fragments of reality. Together they constitute a visual poem in praise of this kaleidoscope of time and change.

HANS SILVESTER

CHANCE, COLOUR AND IMAGINATION

Hubert Comte

Y ou have just returned from Greece; your friends ply you with questions; you tell them about the sun, the journeys, the temples, the museums, the syrupy coffee, the omnipresent glass of water, the kindness and hospitality of people who offer you all they have, although they have almost nothing.... You describe the silvery-green leaves of the olive trees flickering in the wind like shoals of fish in the sea ... the scent of the oleanders....

But surely there's something else. Some wonderful thing that eludes you. A fleeting impression on the first day, blurred subsequently by familiarity born of repetition. That's it.... The colour of a door.... The paint applied year after year, thickly enough to plug the cracks in the wood and smooth the pointed angles of the hinges, to soften sharp edges into wavy lines.

On the island, walking along the quayside, you used to play a game of spotting all the various 'designs' on the doors of sheds, lean-tos and fishermen's stores. Just as if these painted surfaces were people, each with its own distinct expression, its own language. And you would try to make sense of these splashes of colour which, although they might have been applied at random, are nevertheless capable of speaking volumes, depending on how they are juxtaposed, arranged in sequence, or selected – objects of painful economy and simple form, with a sovereign disregard for appearances.

Here are just a few examples of these patterns of colours – muted or brilliant, sparkling or sober, turbulent or calm, standing out against dazzling white walls and façades – together with some observations they inspired. Perhaps it would amuse you to let your imagination roam and try to recognize which is which:

Brushstrokes forming a quincunx: perhaps their message is not to waste paint....

An opening barricaded with old planks, the nails and nail marks still proclaiming, mutely but precisely, their former functions.

A combination of old varnish and faded blue picks out the grain of the wood.

A deep sky blue, the colour of washing blue, dotted with specks of white. These are probably terrestrial oceans seen from above.

A door whose original blue shows through its more recent coat of green is equipped with a padlock that has ceased to serve any purpose.

A cluster of bullet holes resembles a bunch of grapes on a flat surface.

Slowly and patiently the wood of the planks in the door casts off its covering of paint flake by flake.

Dribbles of paint look like tree trunks on a moonlit river bank.

Cracks of red paint appear under the blue, like crimson rivers pouring into a deep-blue lake, viewed from the air.

Initials framed by a heart, painted in broad, determined brushstrokes.

About to rise up and envelop the exposed stones of a wall, a drift of white clouds sails across the blue of the sky.

A door red as the blood of an ox, shiny, shrill as a scream. The painter has just called by....

There was bright green, there were blues, white, a royal blue. A picture. There's a frame. No, it's not an inscription in an unknown language. It's a real picture, a window in a wall. The panes run with condensation from the kitchen ... just beyond lies the sea.

On the door of a shed, trial dabs of paint such as you traditionally saw at the colourist's shop. Vibrations where the paint is overlaid, the undulating lines of the wood fighting against the parallels, the transversal and the diagonal. It's like reading an advertisement: 'Stand still and look at this. It is addressed to you.'

This parade of images, this marriage of choice and chance, where successive layers of paint fight an unfair battle with sun, sea, the salty air and rain; where phantasmagorical apparitions emerge out of flux, according to the mood of the passer-by and the nature of his or her obsessions; where time presses on

regardless, inexorable and unforgiving.... It is a kaleidoscope that lays bare the lines of force and throws off a flurry of unexpected insights, those little discoveries that instantly infiltrate your life....

Otherwise, what would be the point of books?

The type of paint is relevant, being for the most part that used to protect the hulls of fishing boats. Ultra-resistant and strongly adhesive, it forms a shell-like armour plating, quite unlike wax which penetrates the wood and is absorbed by it.

Over a period of six years, Hans Silvester returned many times to these islands to photograph the cats that share the territory with its human occupants. Patient observation, constant patrolling, keeping watch, long periods of waiting, moments of surprise, disappointment and success ... you can imagine how his days were spent.... Almost inevitably, another project emerged to occupy the times in-between: that of capturing, in moments of luminosity, the strange beauty of the coloured surfaces he encountered along the way.

It takes a very special eye to see such visual effects, an eye that can find sense in almost anything, be it an intangible reflection in water or the shifting silhouette of a cloud.... Two dabs of paint, a shape, and the imagination is unleashed. It is an exercise in concentrating one's attention, not dissimilar to looking at the works of modern painters, focusing on all that is risky, anonymous, temporary and without value....

For it is our observation that invests things with value. And our observation is sharpened by use, so that new paths lead us towards the many crossroads of our future. This book takes us on a journey with only ourselves for company. It shows us how to look about us, at the objects that surround us; how to find wonderful things inscribed on walls: it demonstrates that even random effects are interesting. It makes us dream, and dreaming opens up the way to other discoveries.

Lessons in modesty and curiosity, these images are imbued with calm and content. The music of time plays softly over the things of this world. We are in good company surrounded by these reminders of the past. We can feel the presence of others leading us by the hand.

CAPTIONS

9 This door keeps the small fishing boats sheltered safe from the storm. Milos.

10 Façade of a holiday house resembling a stage set. Thirassia.

11 Ready for hanging out the washing. Sifnos.

12 Iron door leading to a small boatyard. Syros.

13 Damp patches on a house near the sea. Tinos.

14 A garden gate cobbled together by a fisherman. Amorgos.

15 Old advertising sign. Mykonos.

16 Well and wine cellar hollowed out of the volcanic soil of Santorin.

17 Painted steps. Syros.

18 Arrow pointing to a bar. Santorin.

19 Painted motif on a garage door. Naxos.

20 The shadow of a balcony creates this effect of light and shade. Anafi.

21 Door of an abandoned house. Santorin.

22 Trying out paints and brushes in a boatyard. Syros.

23 Anti-rust paint on the hull of a boat. Amorgos.

24 Touched-up paintwork on a fishing boat. Mykonos.

25 Patch of blue wall that looks like sky. Syros.

26 Small stones embedded in roughcast to decorate a wall. Santorin.

27 Play of light on a battered metal surface. Andros.

28 Geraniums growing in a specially built and decorated tub. Santorin.

29 Detail of the hull of a fishing boat, resembling a landscape. Paros.

30 Drawing on a garage door. Syros.

31 No Parking. Syros.

32 Metal cask. Tinos.

33 Hull of a sailing boat under repair. Paros.

34 Abandoned house, whose occupants must have emigrated. Tinos.

35 Kitchen window. Paros.

36, 37 A shaded stairway is lit by a few rays of sunlight. Santorin.

38 Bullet holes in an abandoned car. Amorgos.

39 Paintwork on agricultural machinery. Naxos.

40 Coloured marks on a metal gate. Naxos.

41 Ventilation holes in a cellar door. Mykonos.

42 Peasants' benches in front of a farmhouse. Tinos.

43 Novelty broom. Santorin.

44 Remnants of posters. Mykonos.

45 Cracked old wood looking like eyes in a face. Syros.

46 Blue is the Greeks' favourite colour. Door in Santorin.

47 Public road from the harbour to the village. Ios.

48 Stable door. Syros.

49 Paint marks on a metal surface. Naxos.

50 Old election poster. Syros.

51 Paint on a shop window. Milos.

52 Detail of the façade of a house. Syros.

53 Hull of a fishing boat, with seaweed. Tinos.

54 Patches of colour on the roughcast exterior of a house. Syros.

55 Door of a workshop in a boatyard. Sifnos.

56 Closed shutters of an abandoned house. Syros.

57 Detail of the rudder of a fishing boat. Mykonos.

58 Colours of time, wall in Syros.

59 Orange tree in front of a house. Syros.

60 Garden gate. Milos.

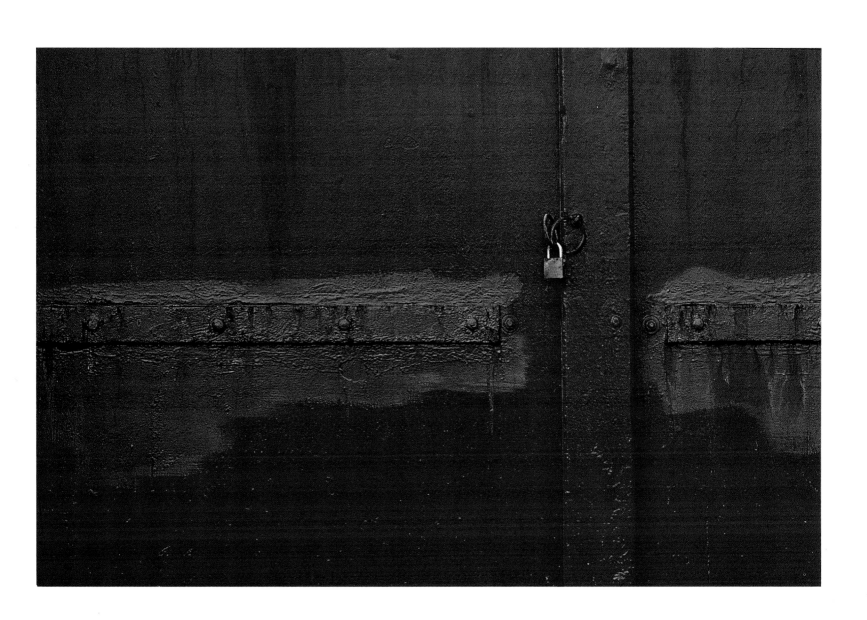

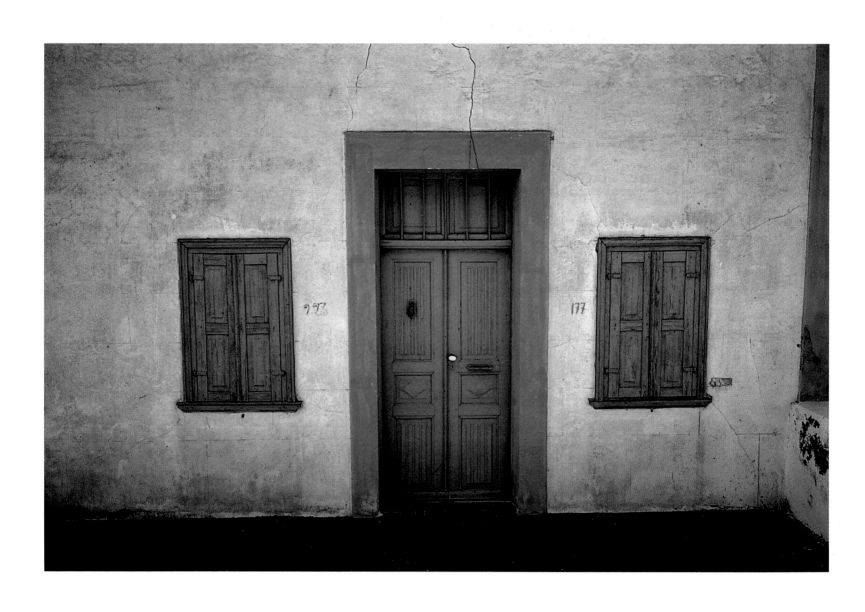

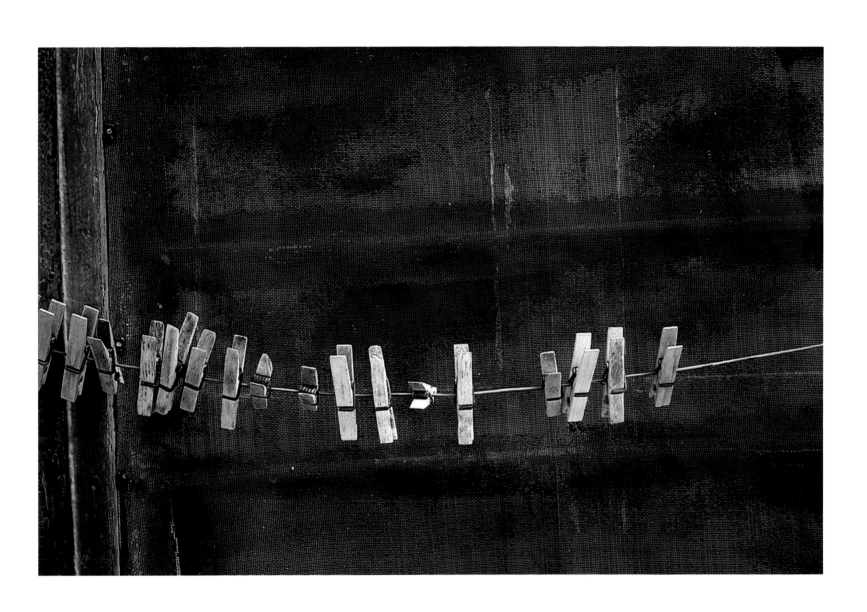

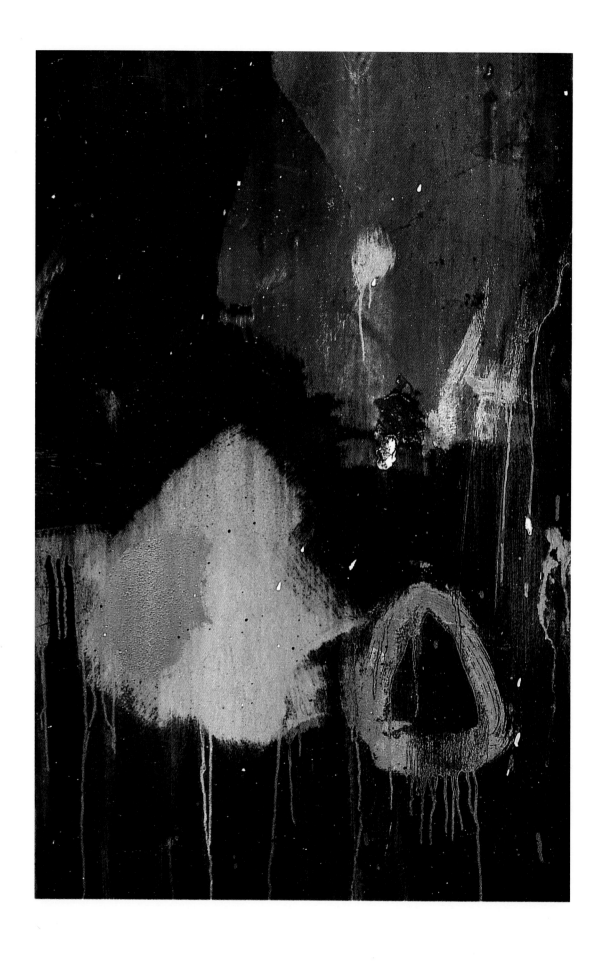

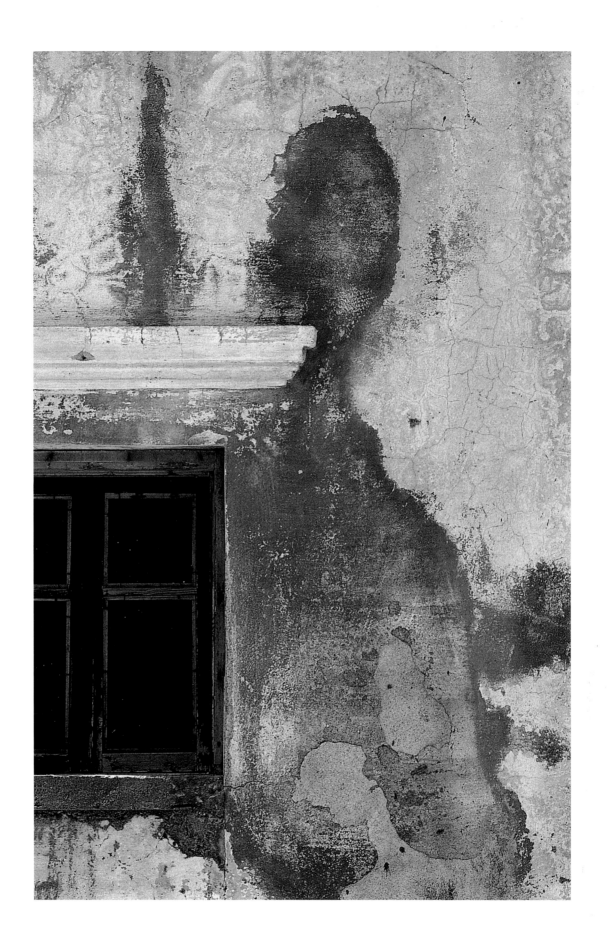

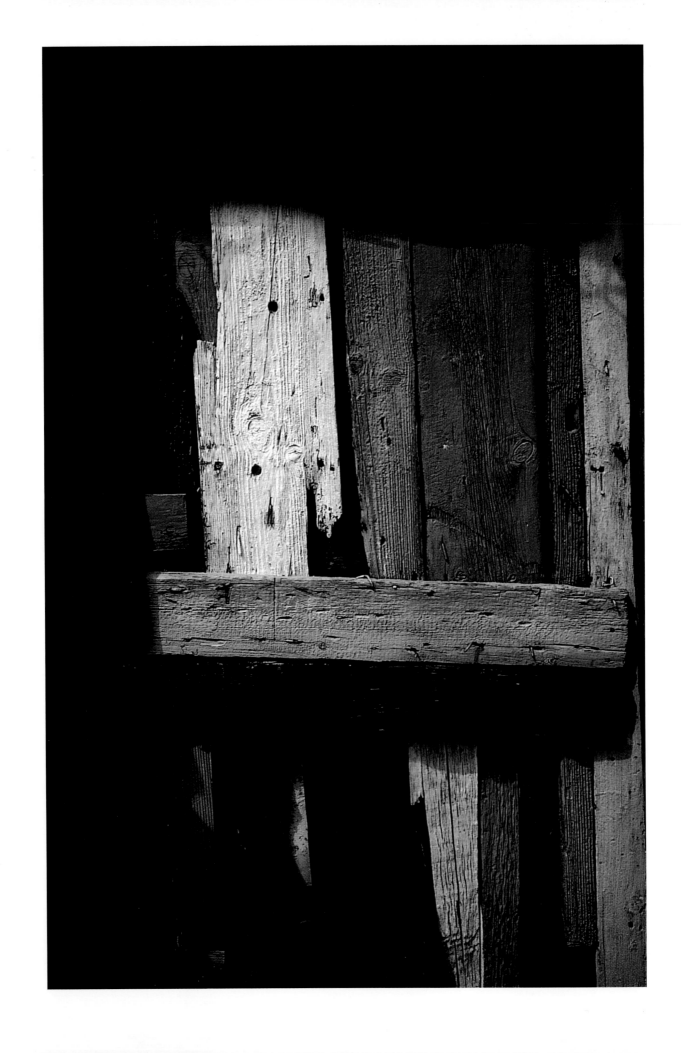

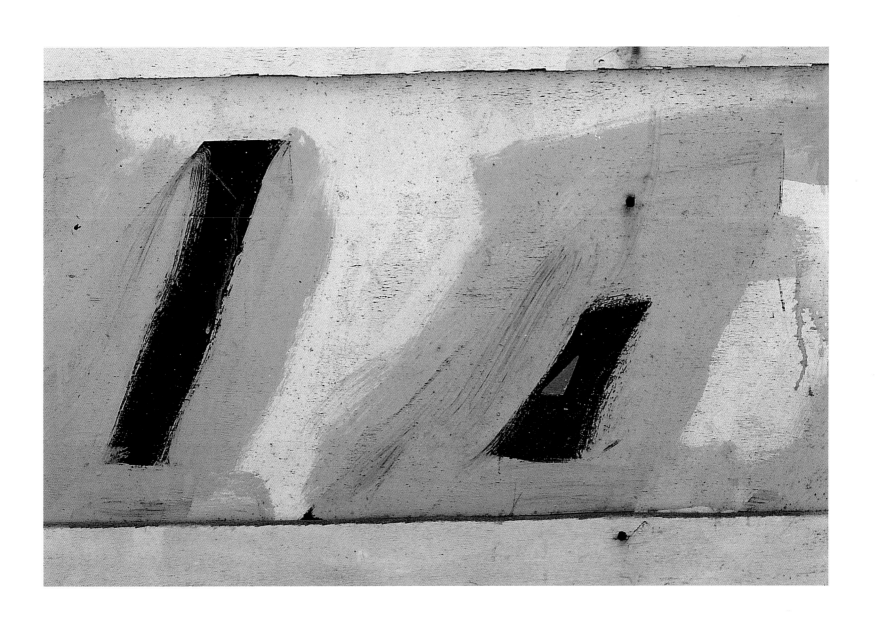

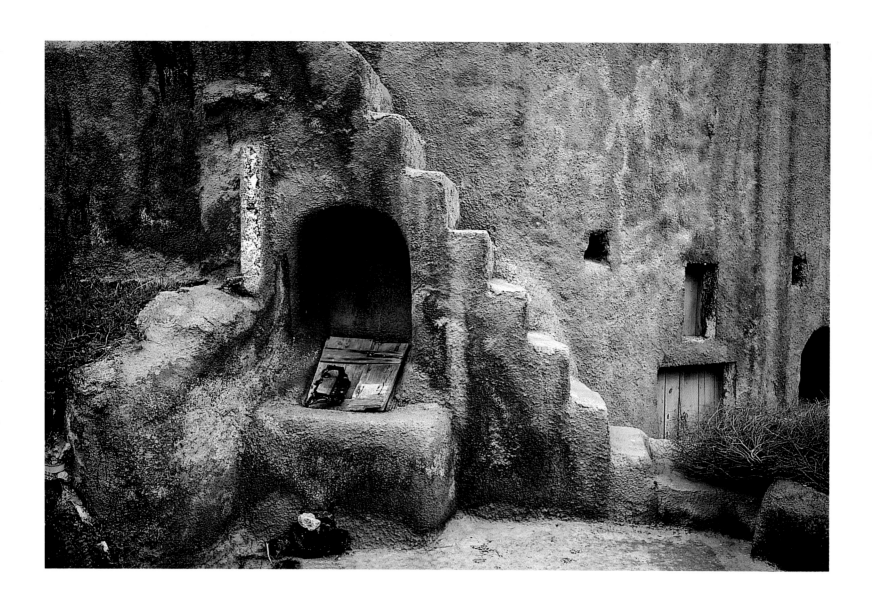

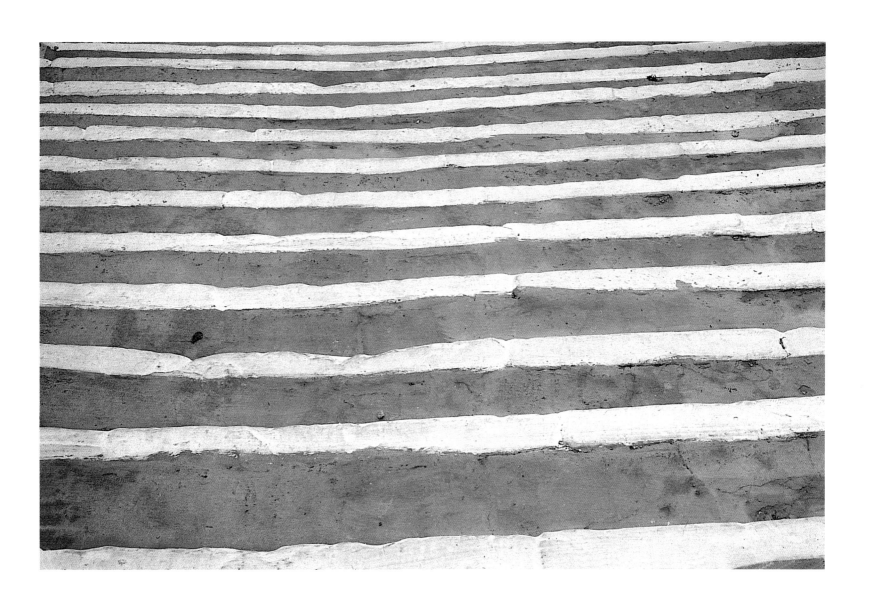

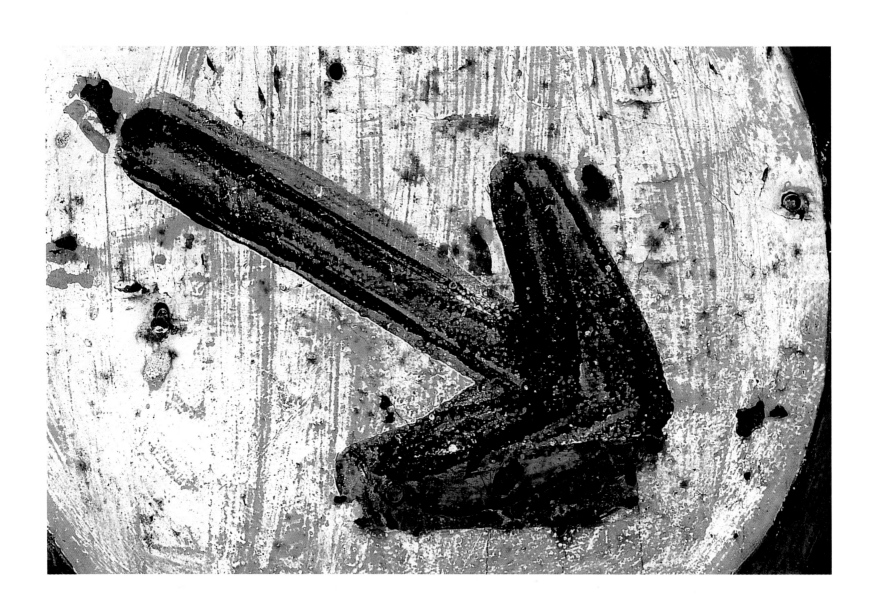

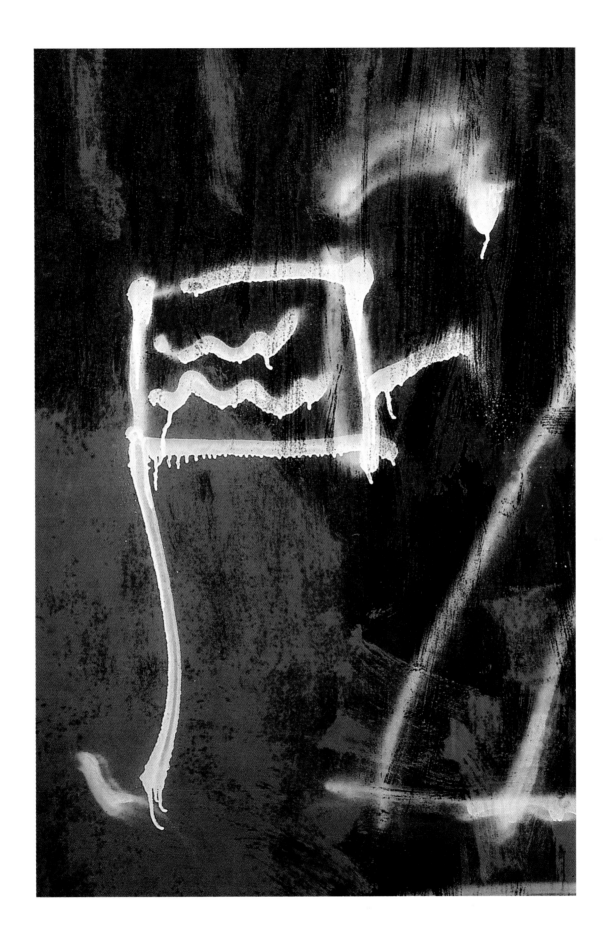

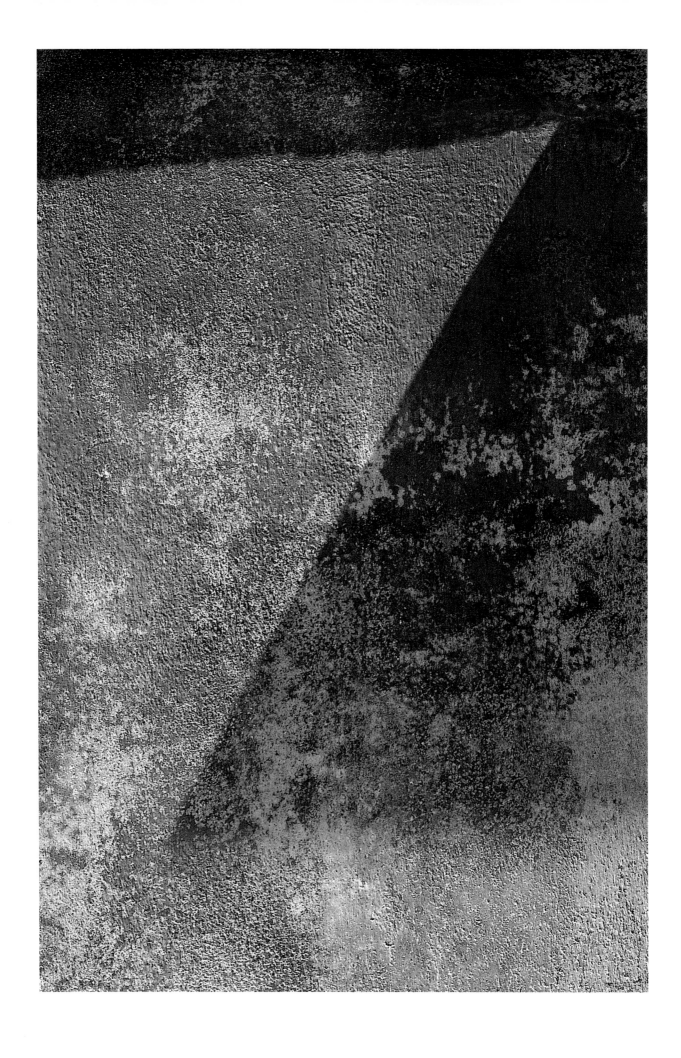

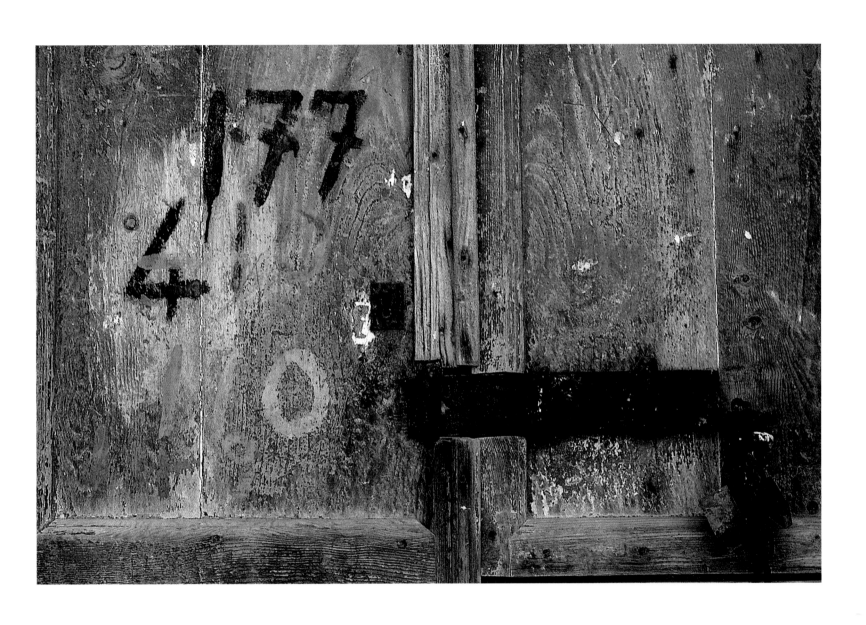

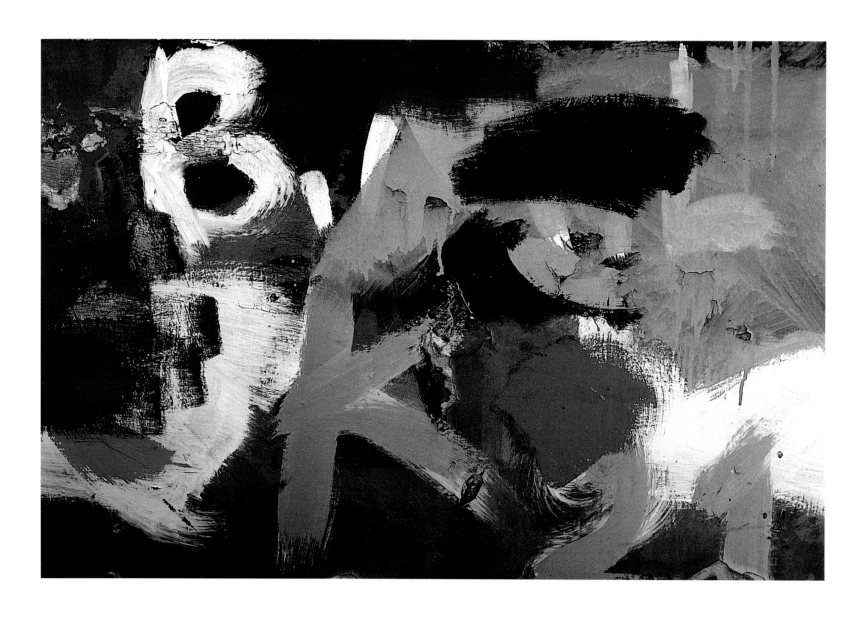

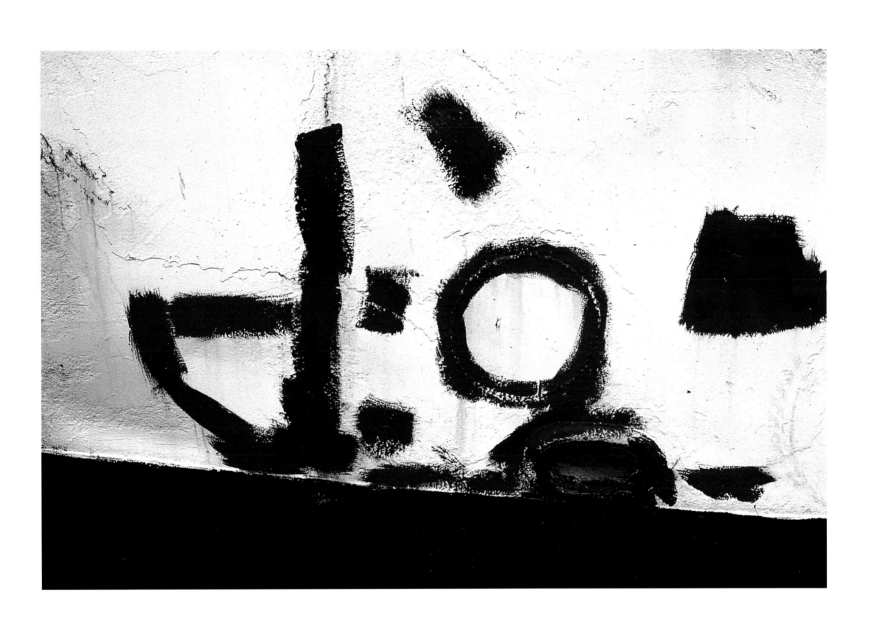

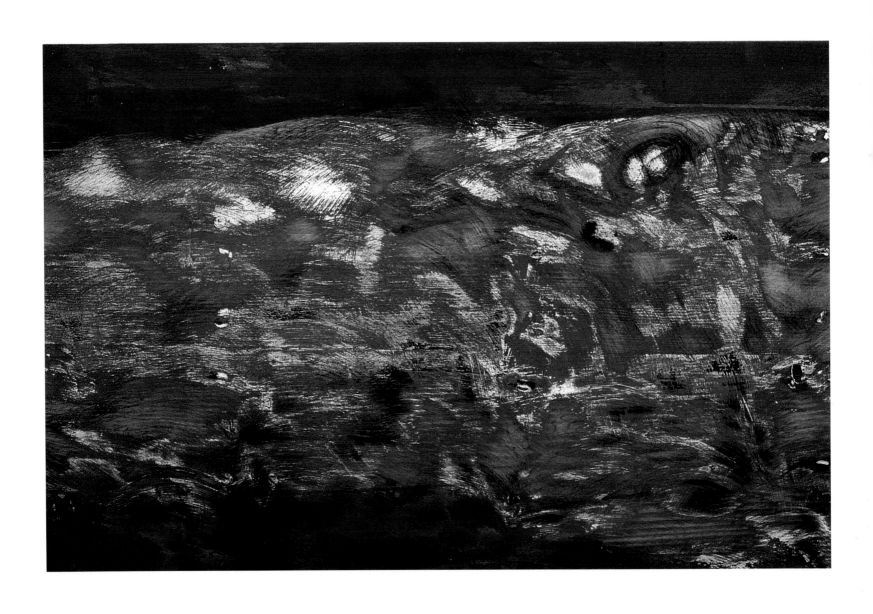

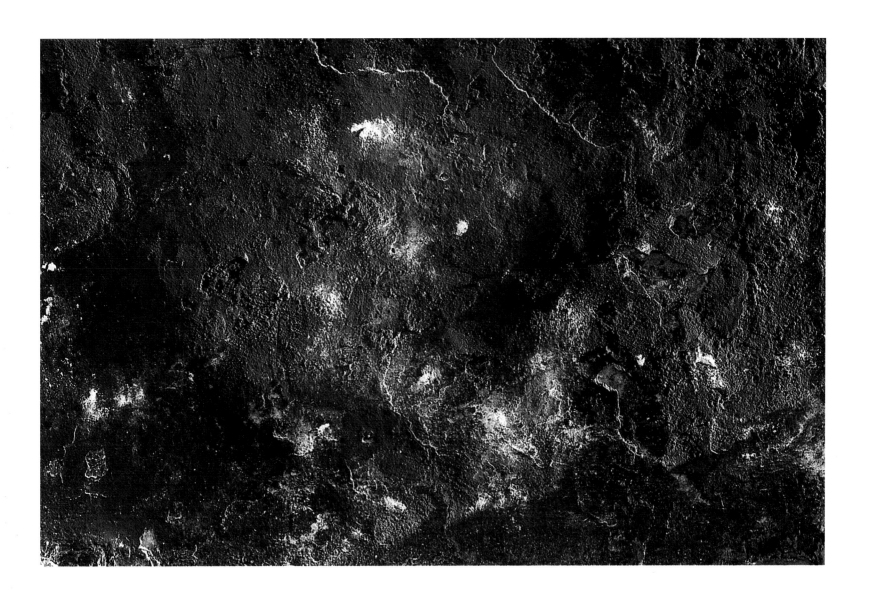

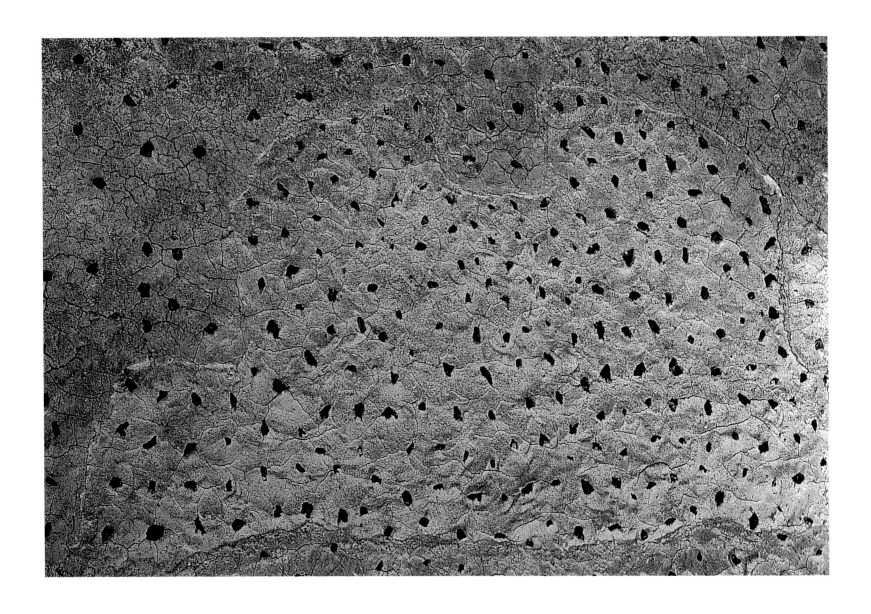

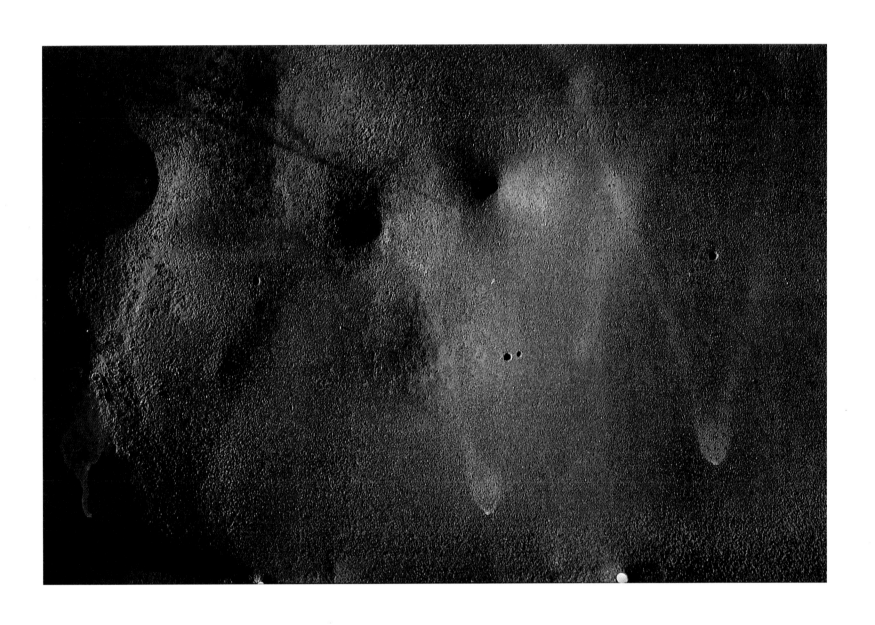

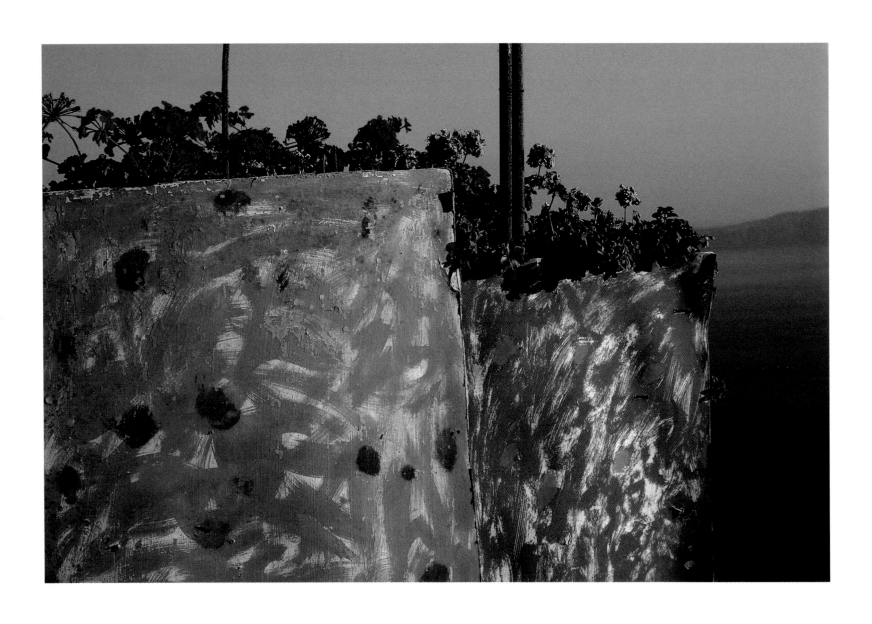

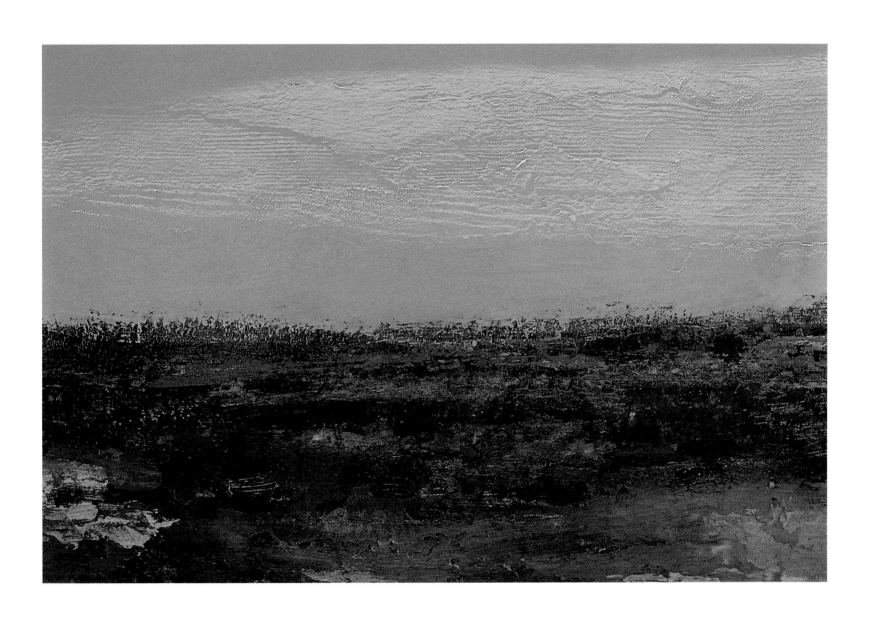

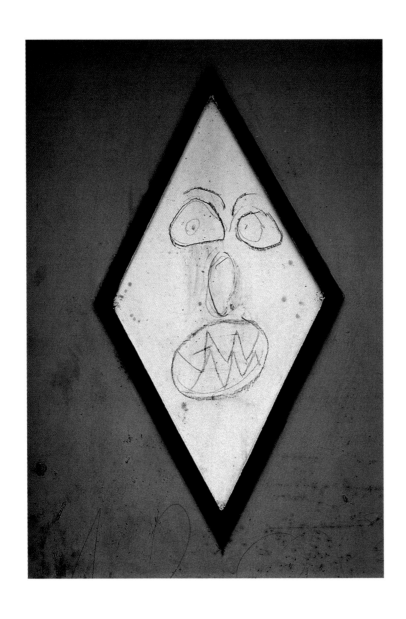

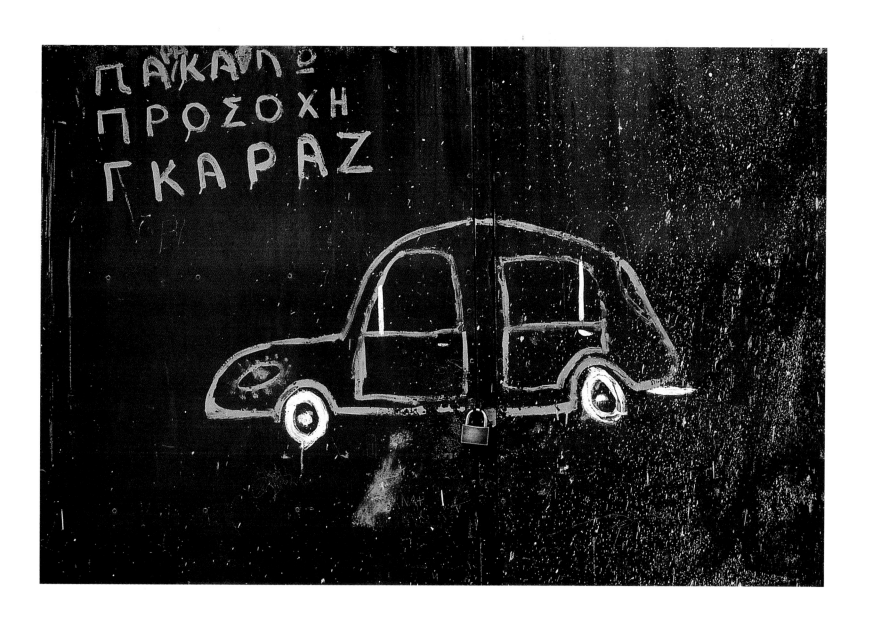

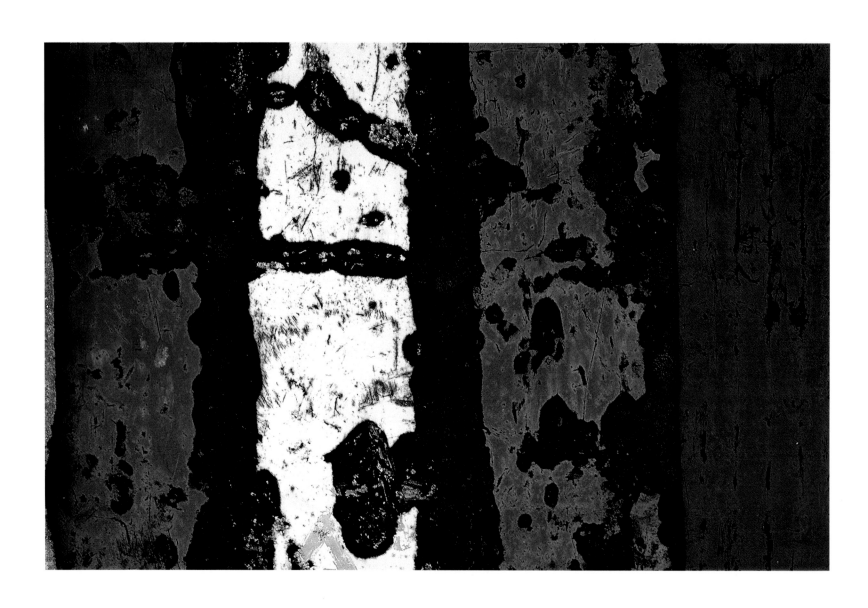

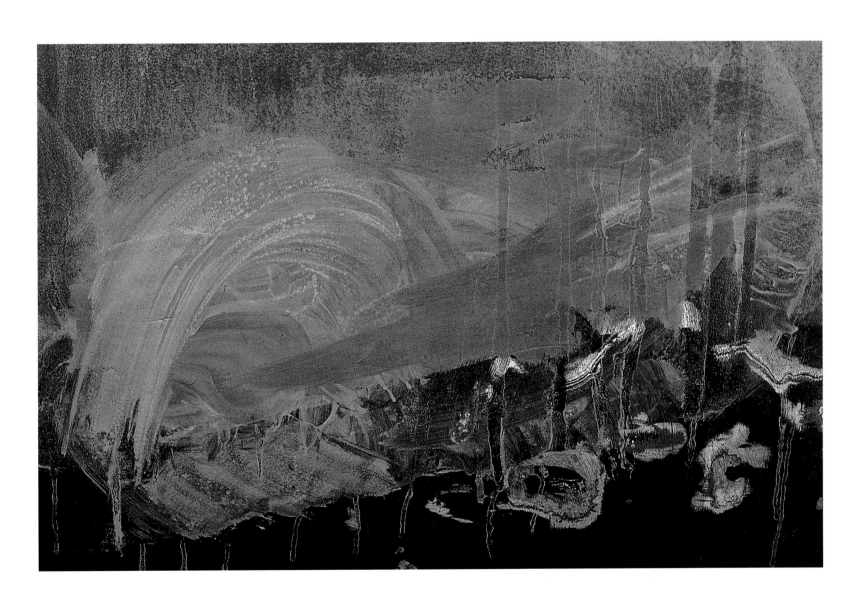

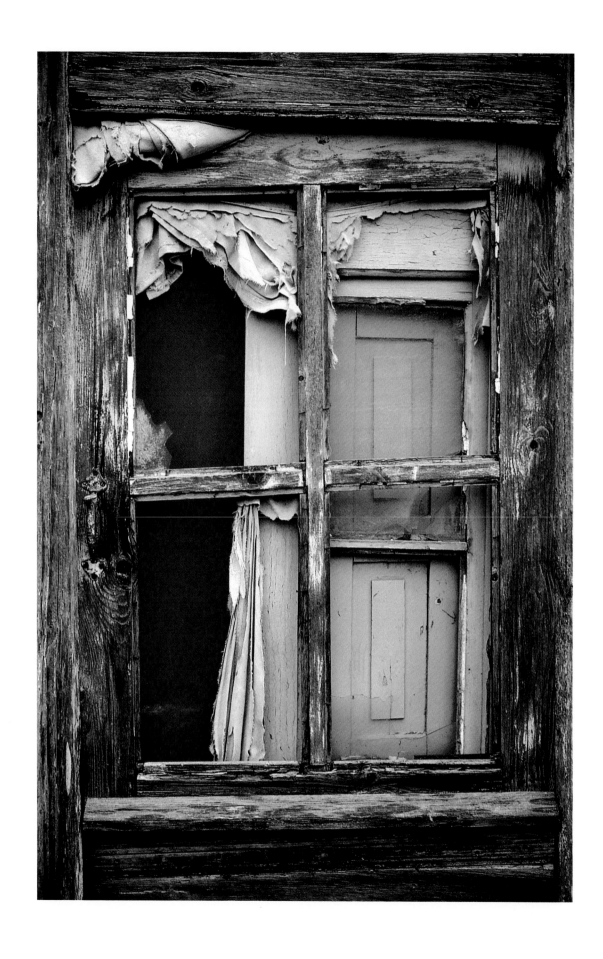

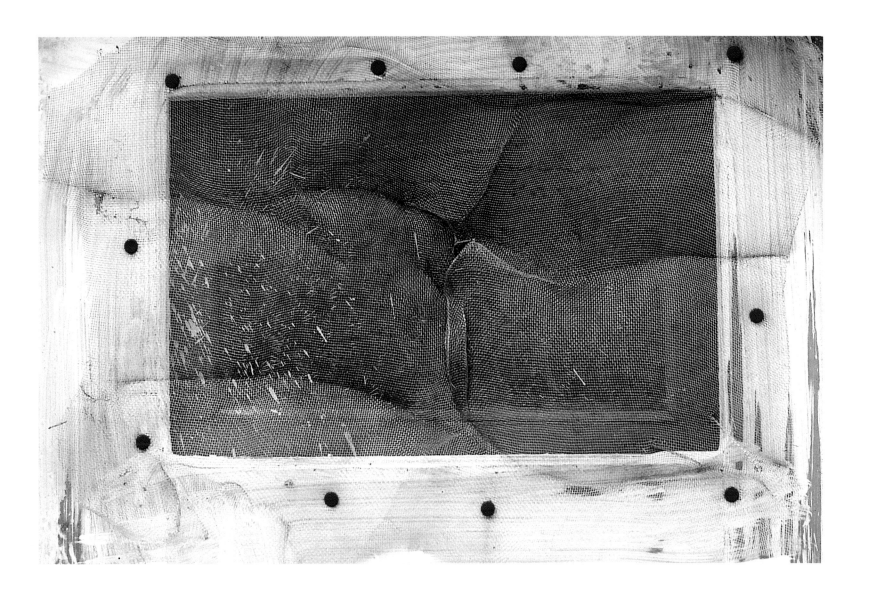

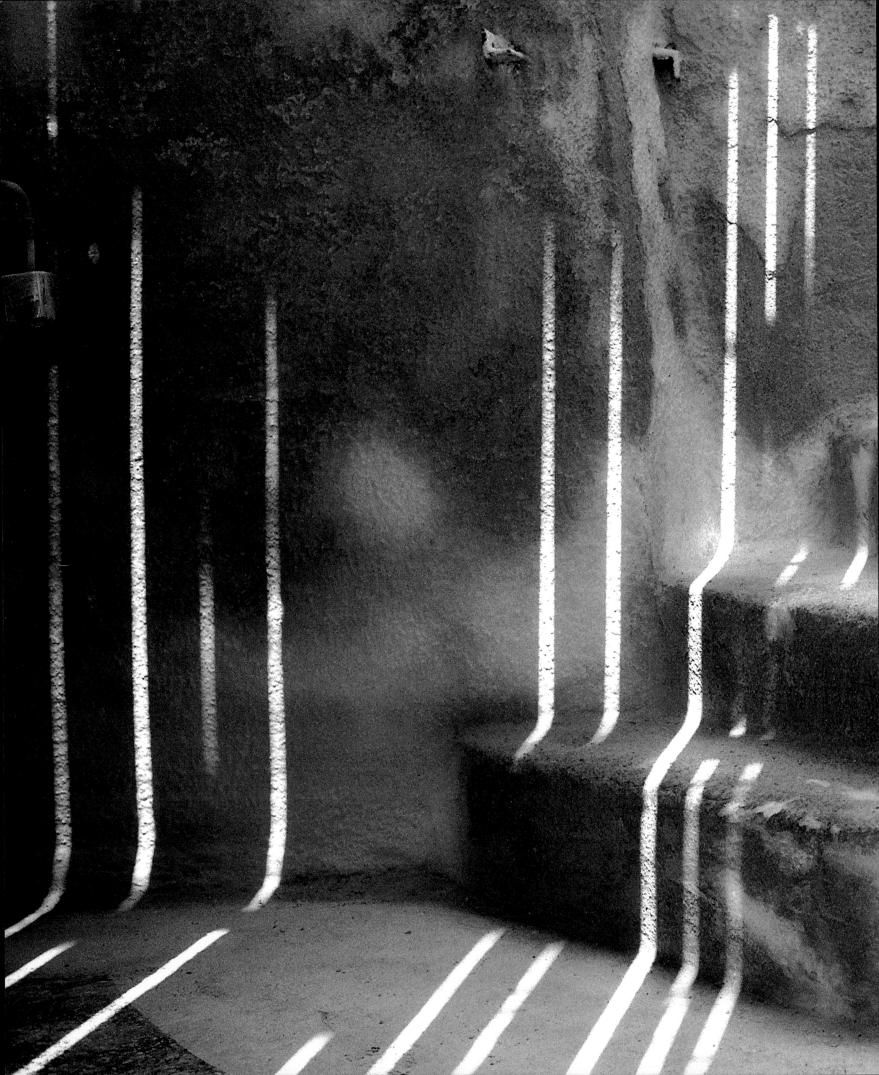

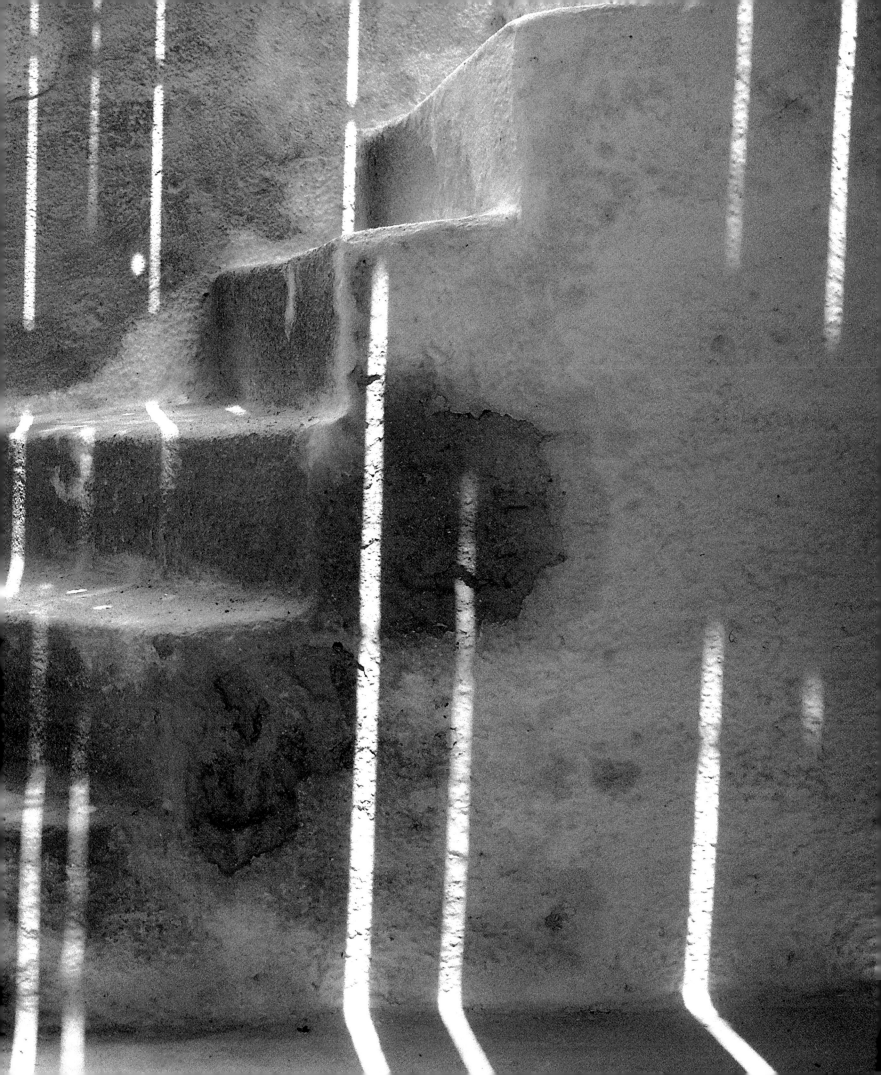

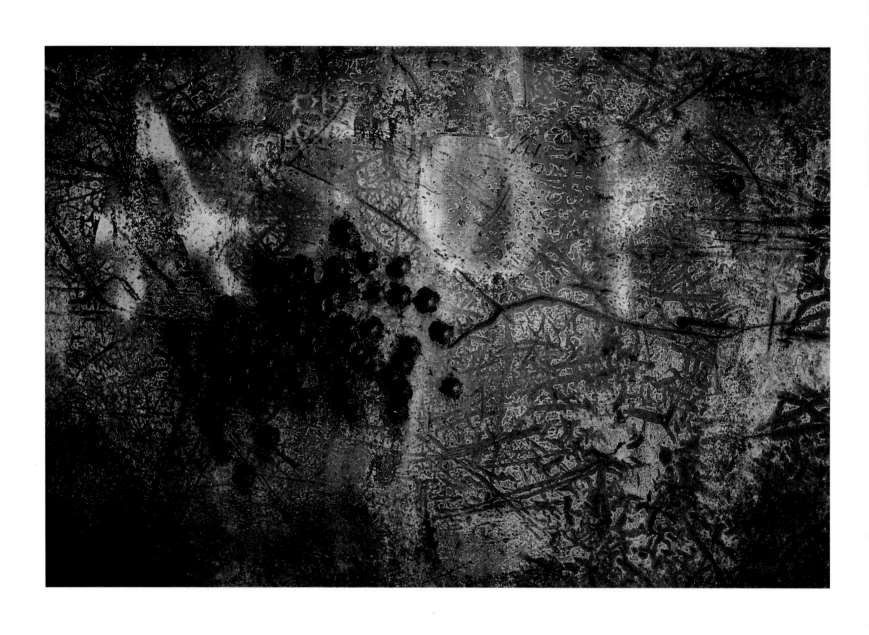

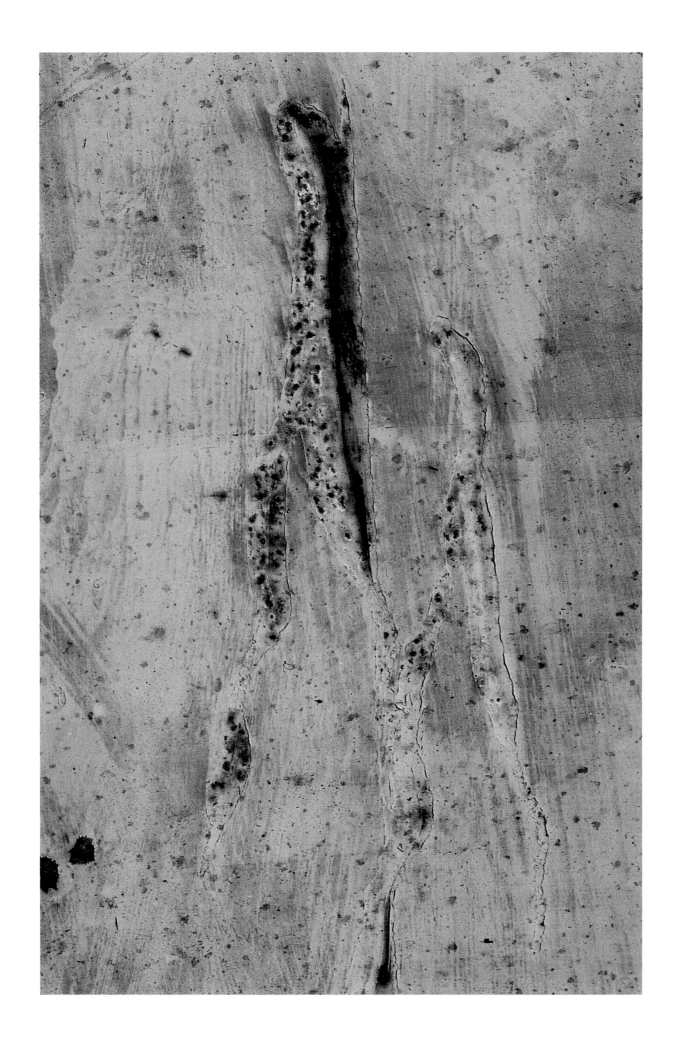

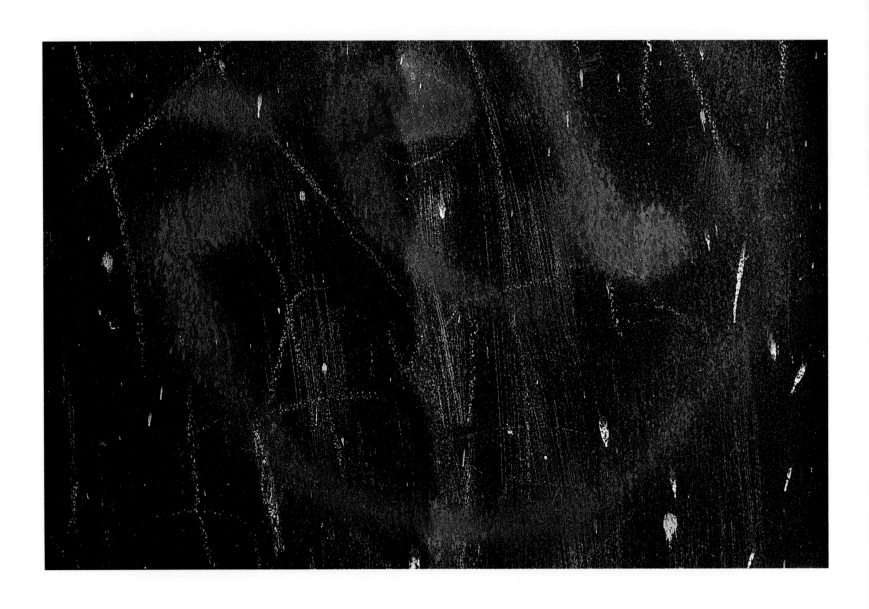

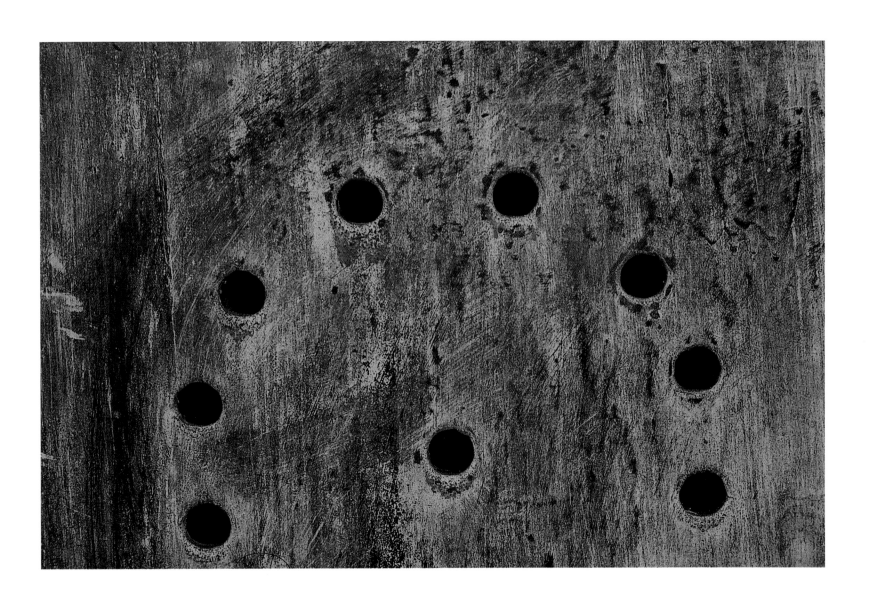

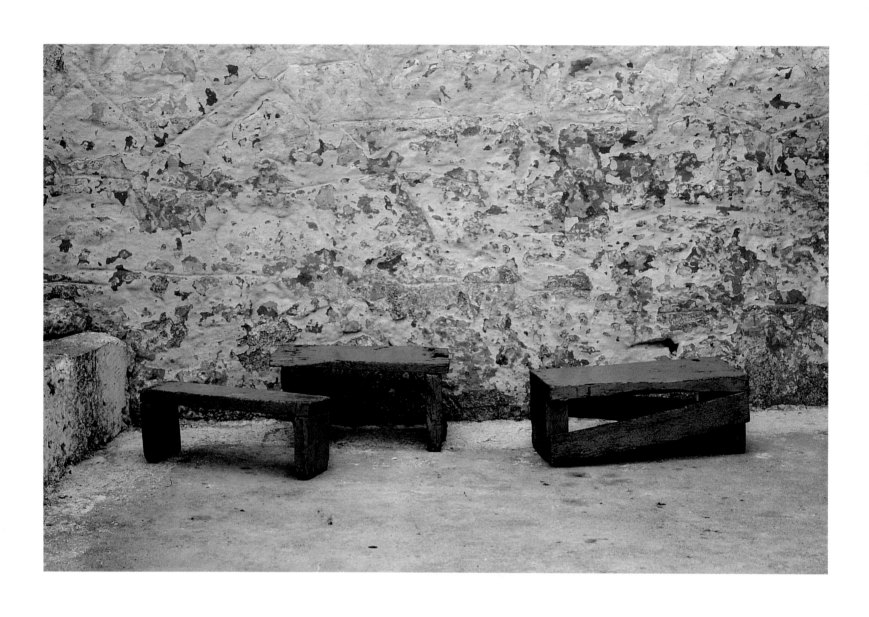

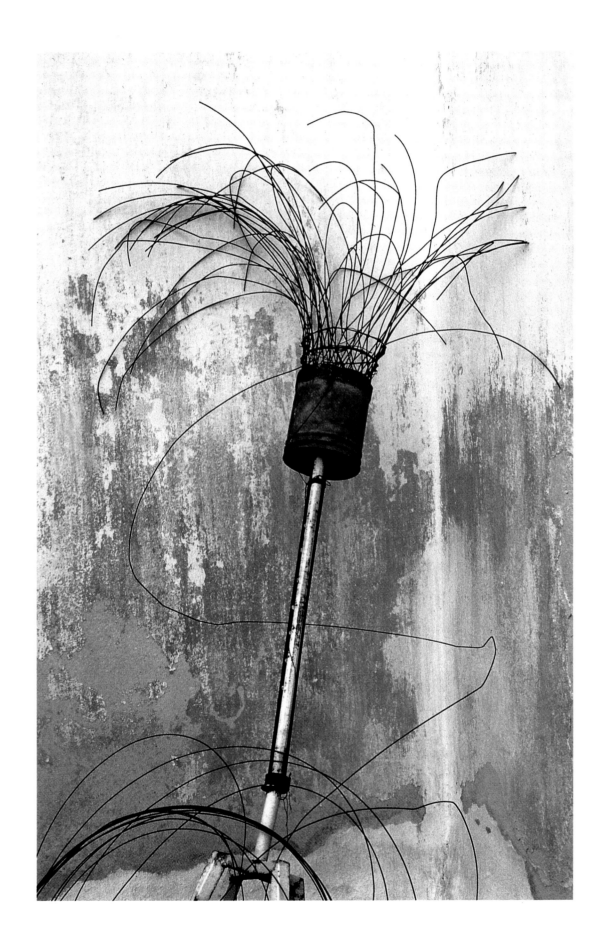

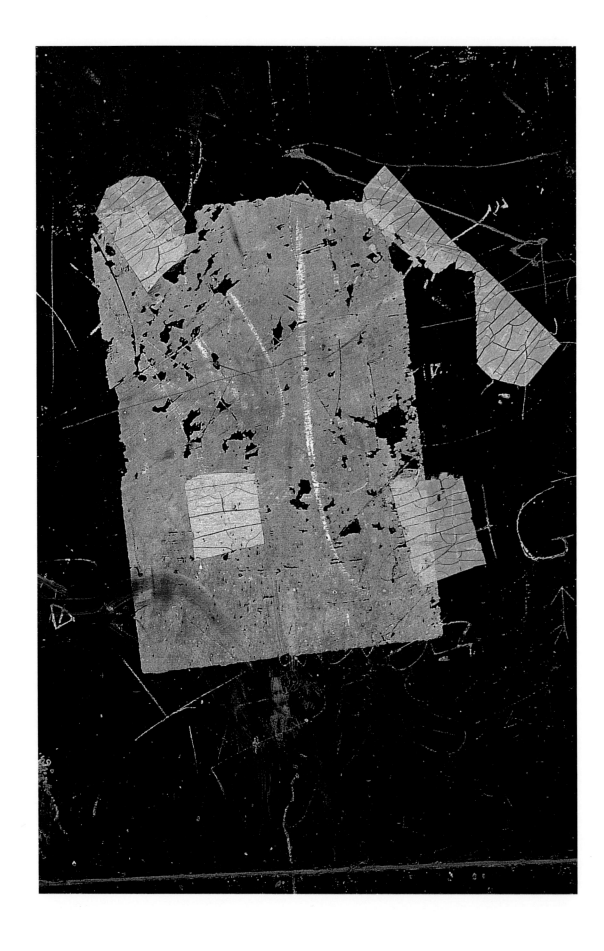

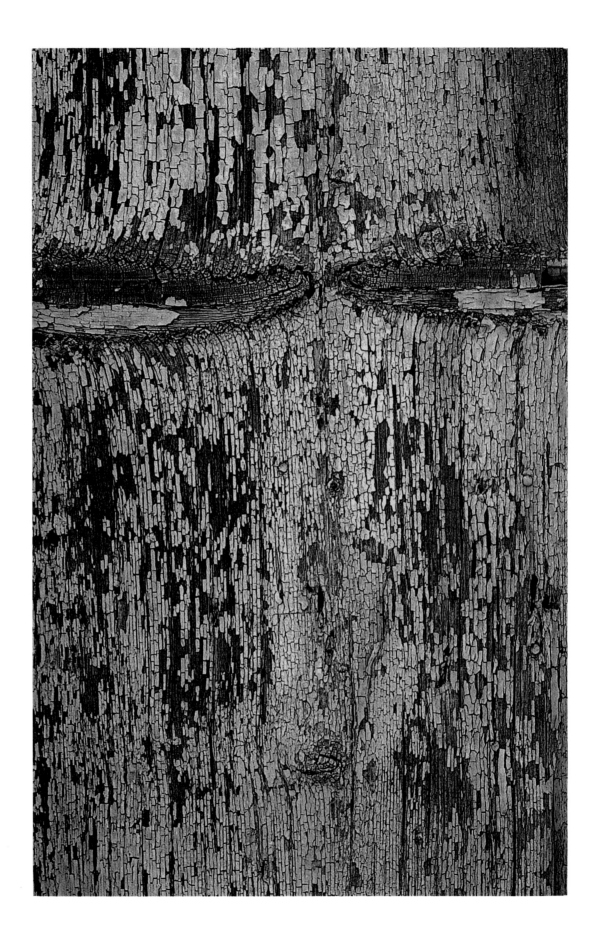

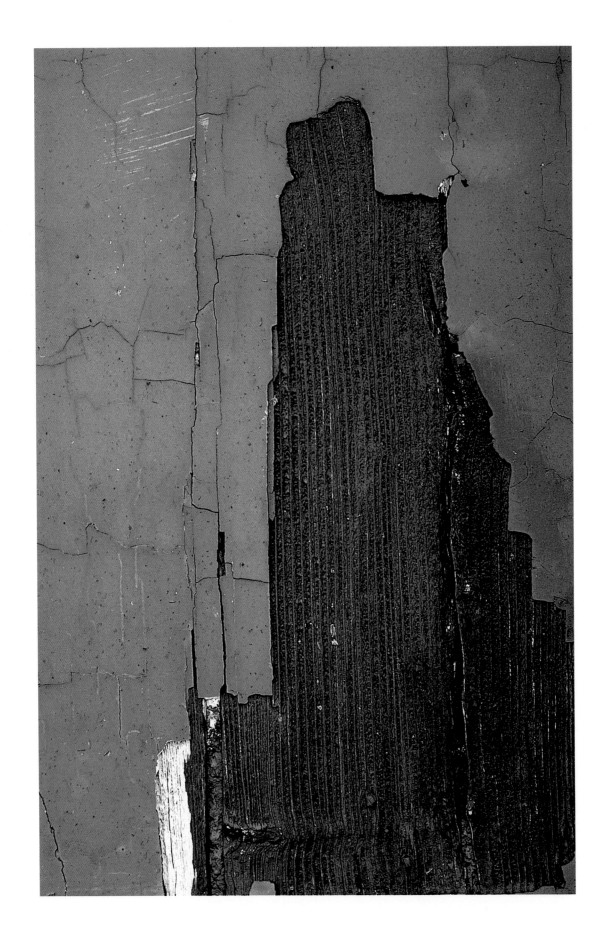

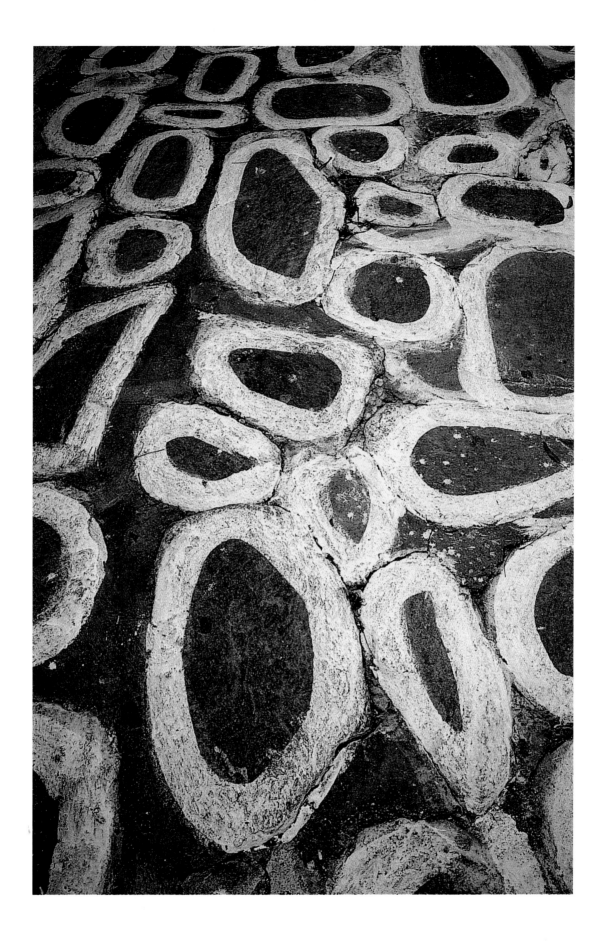

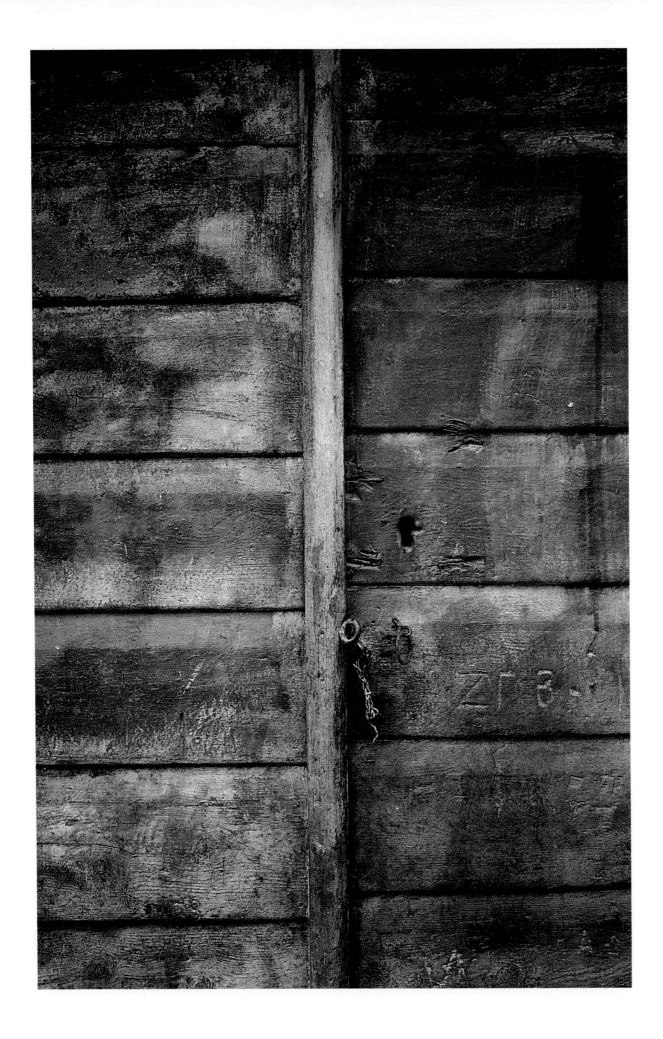

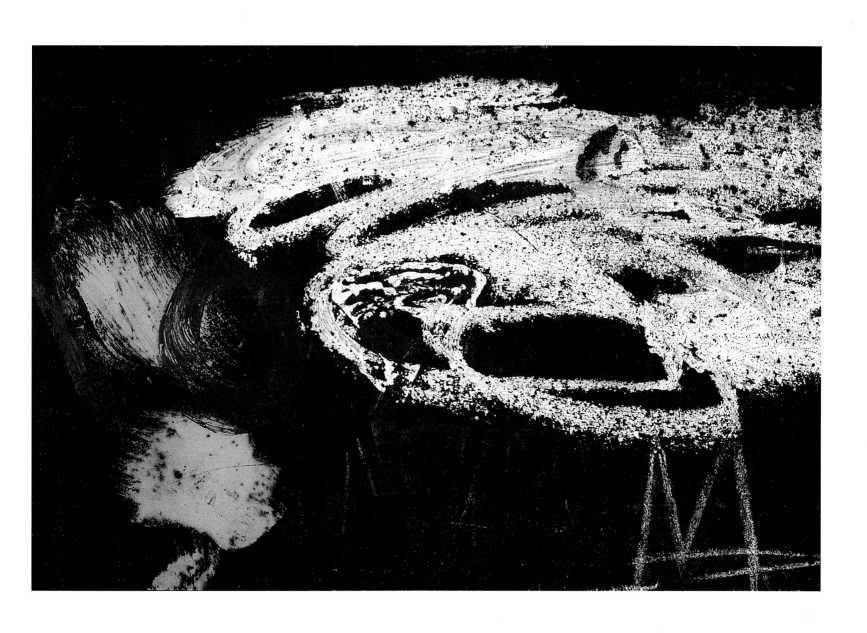

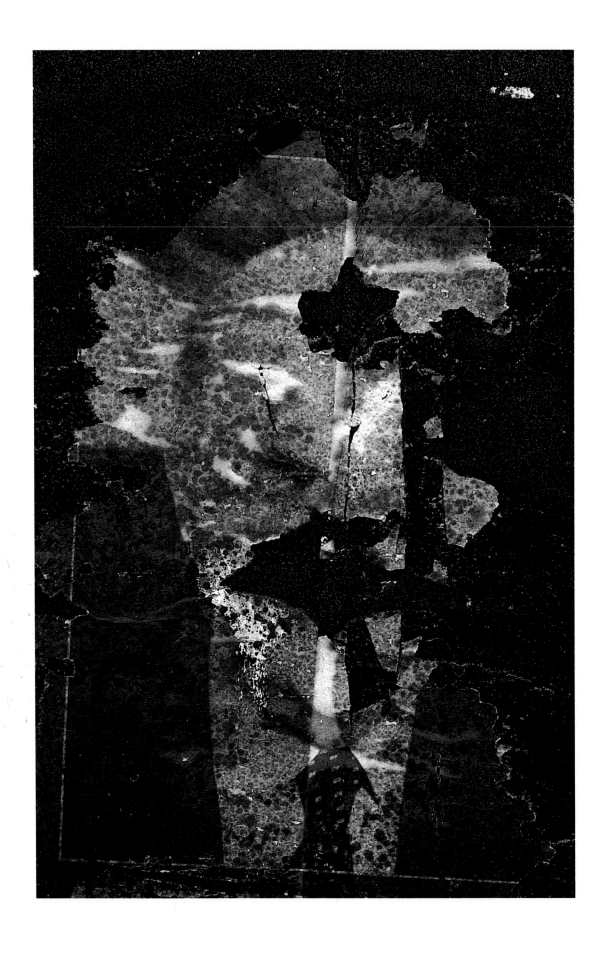

50

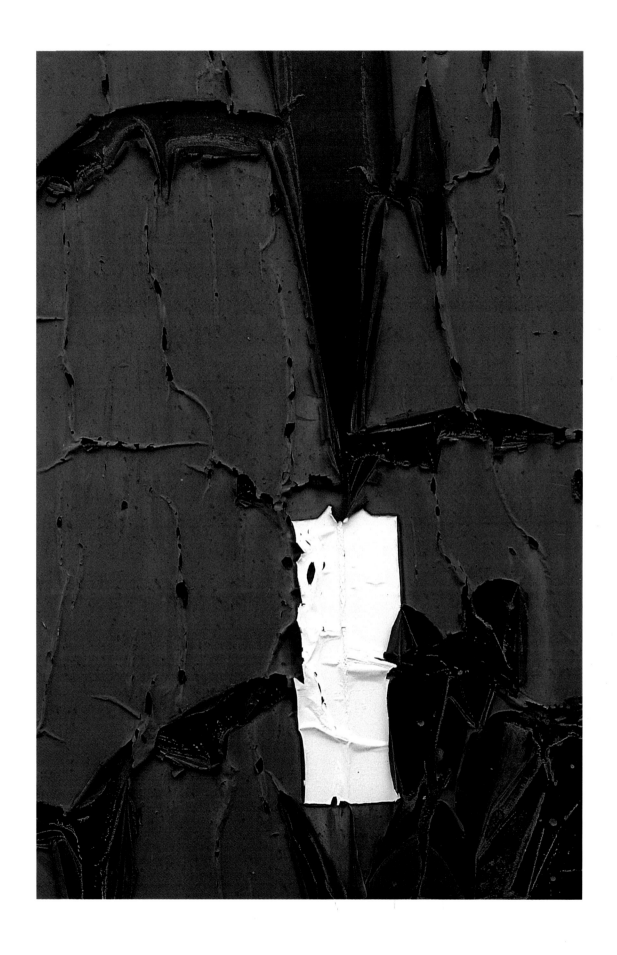

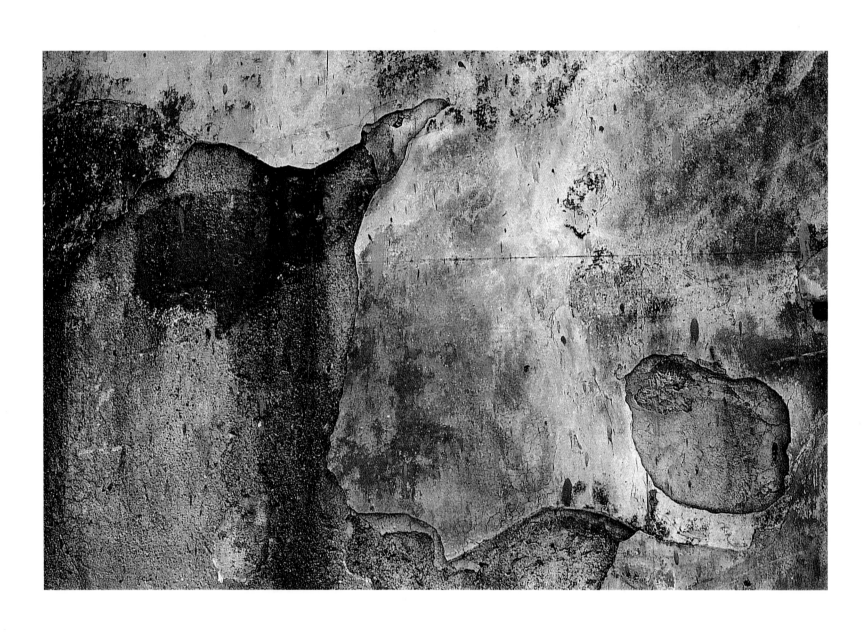

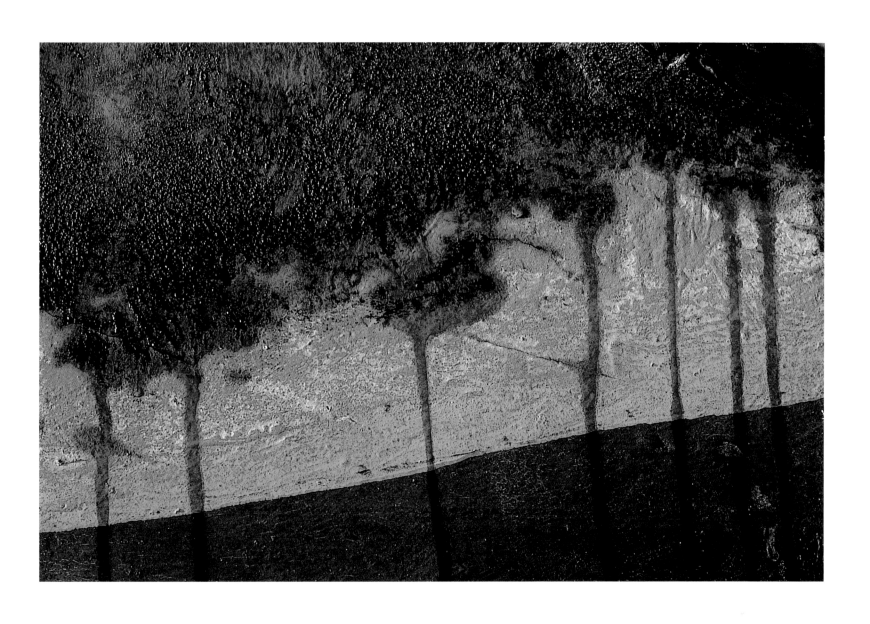

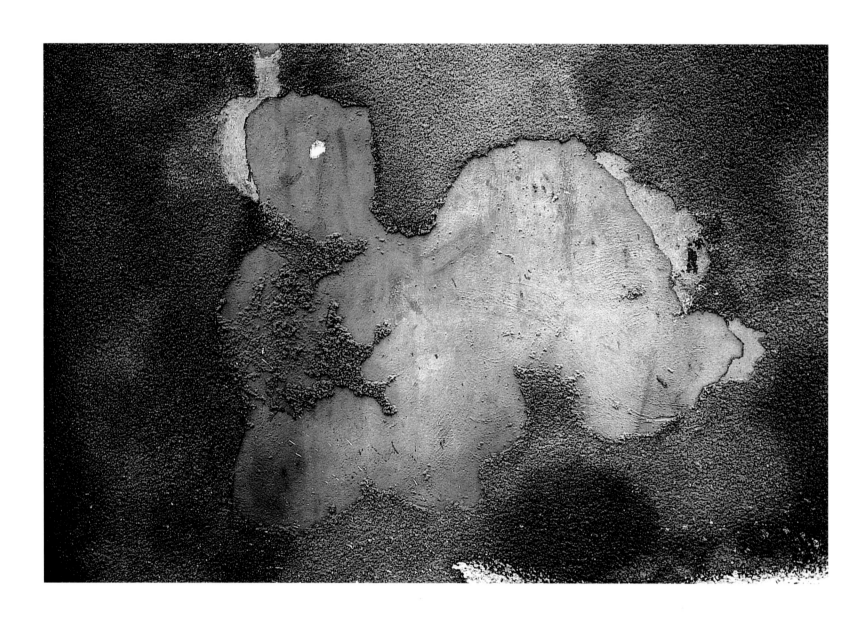

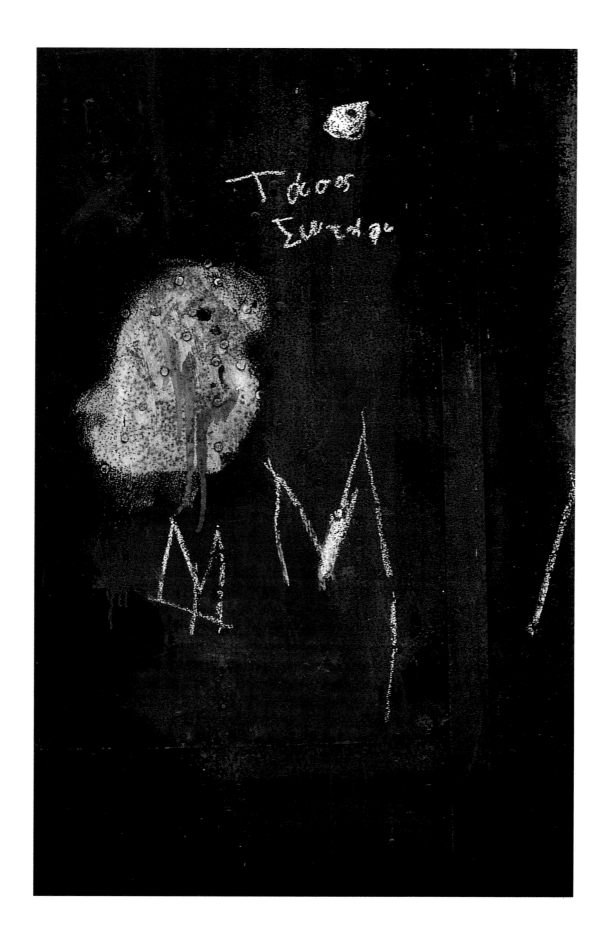

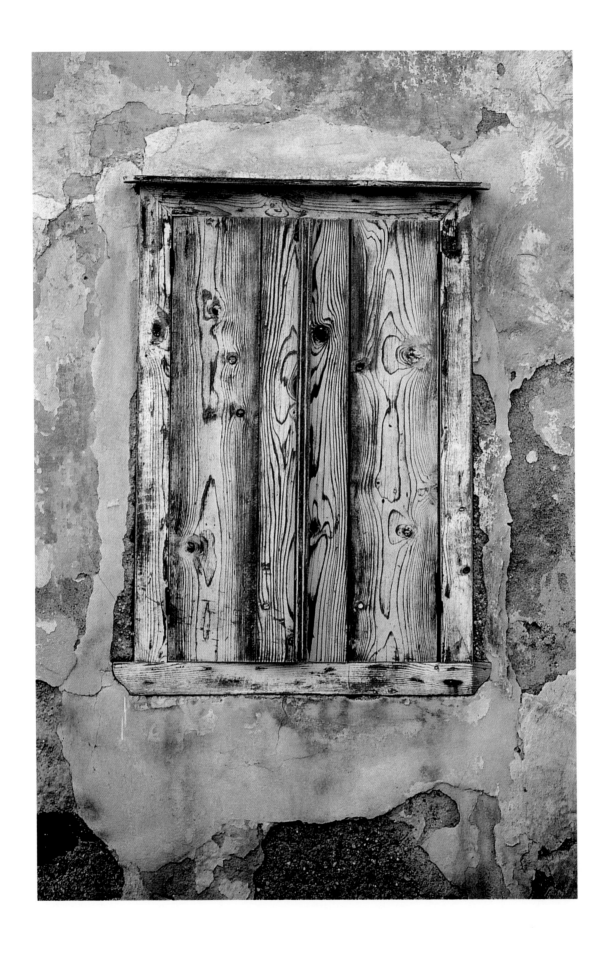

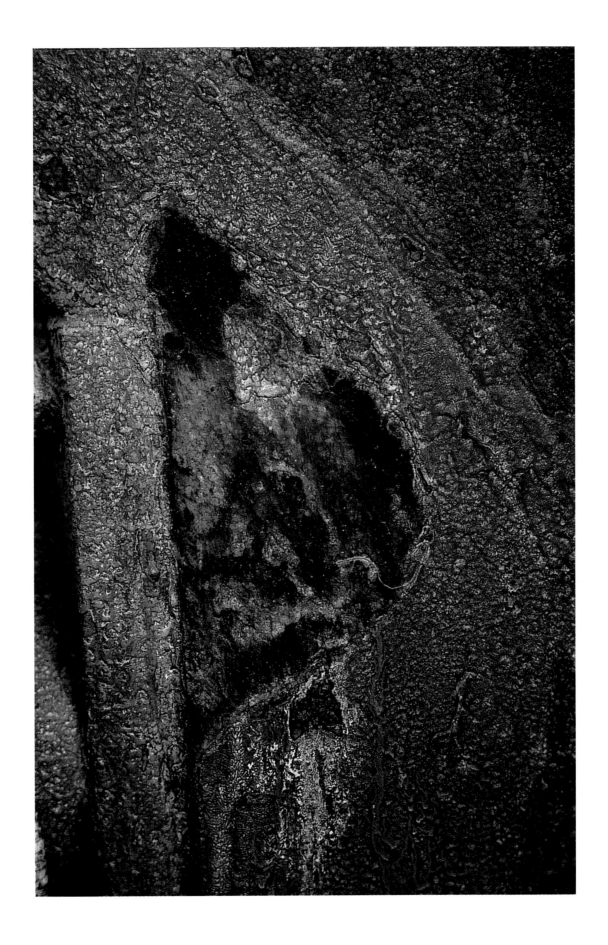

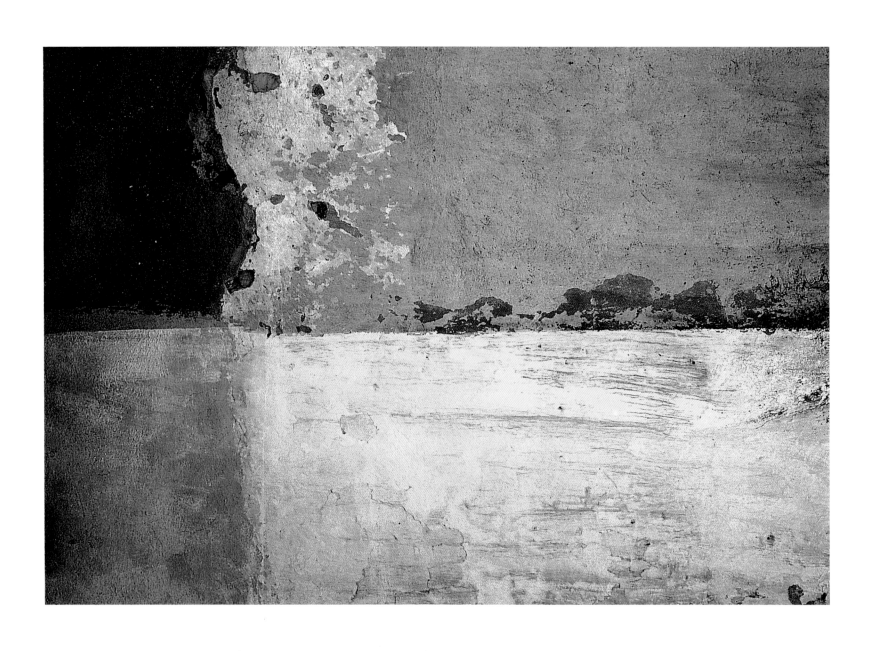

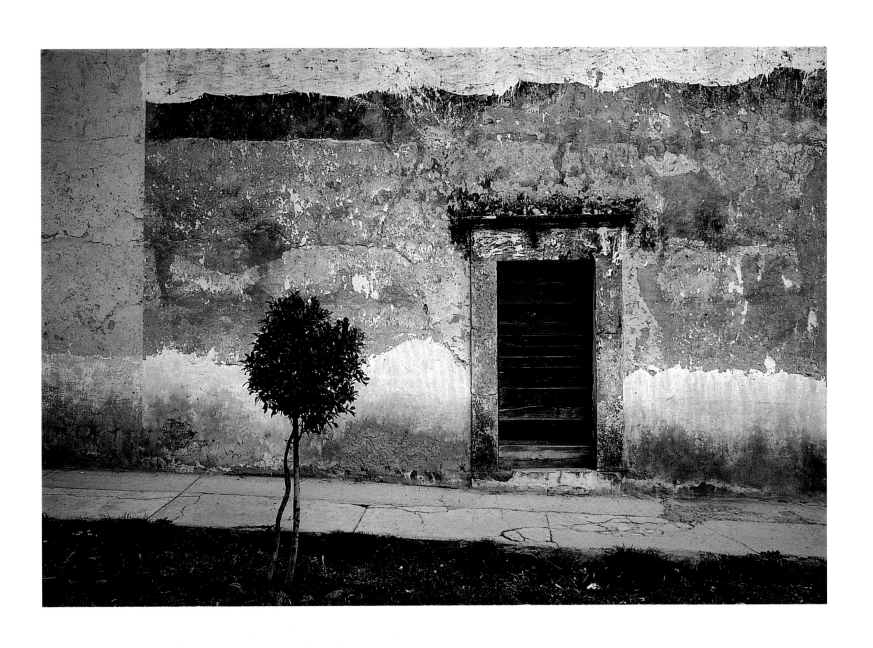

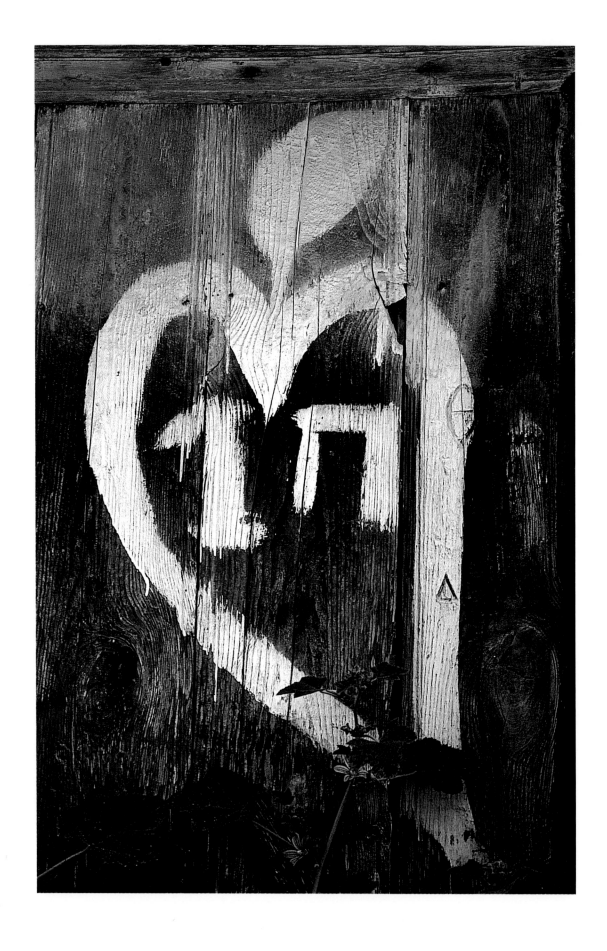

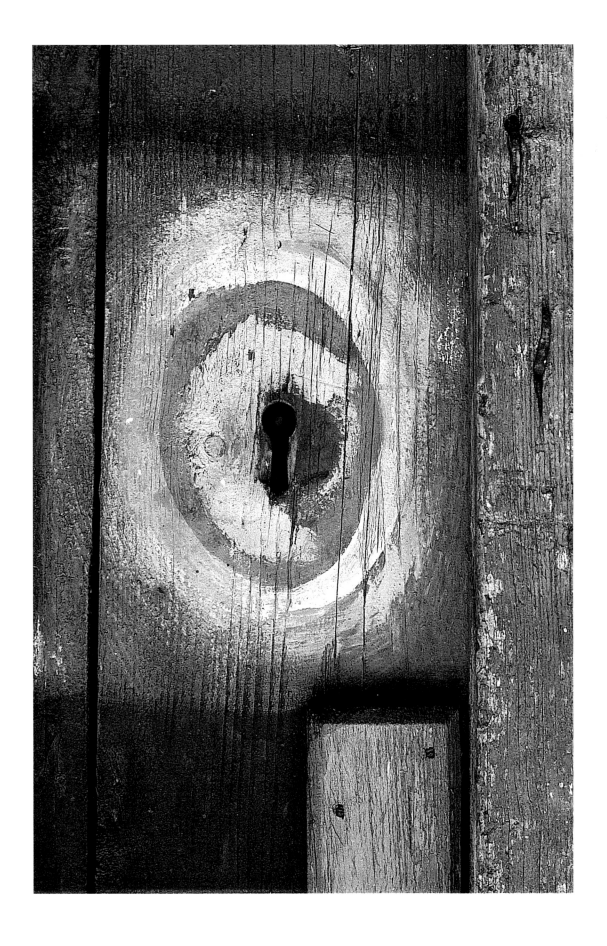

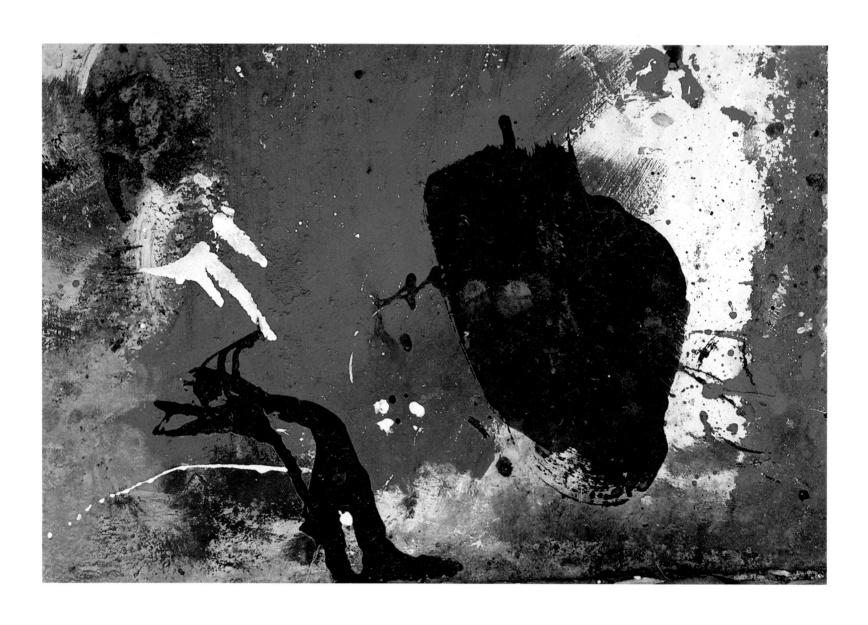

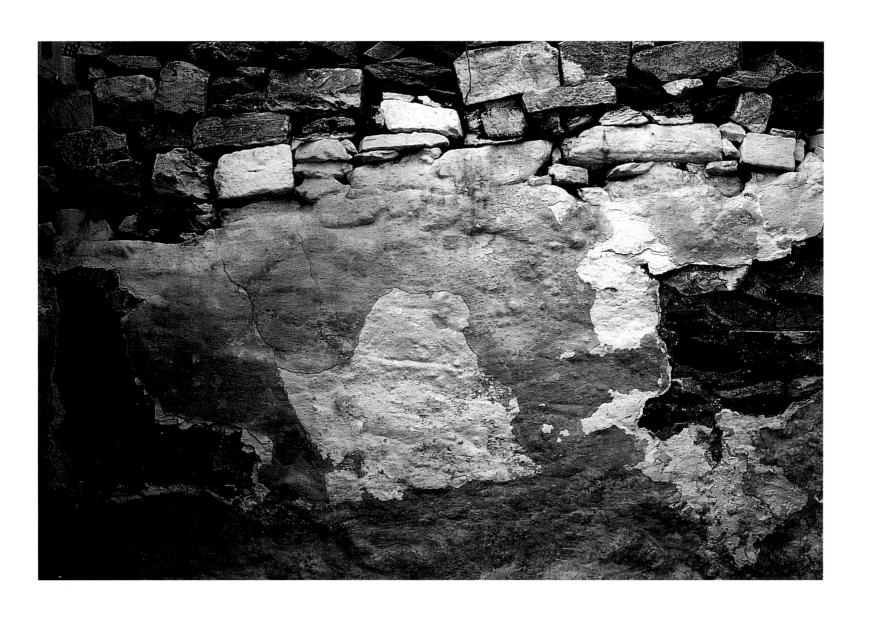

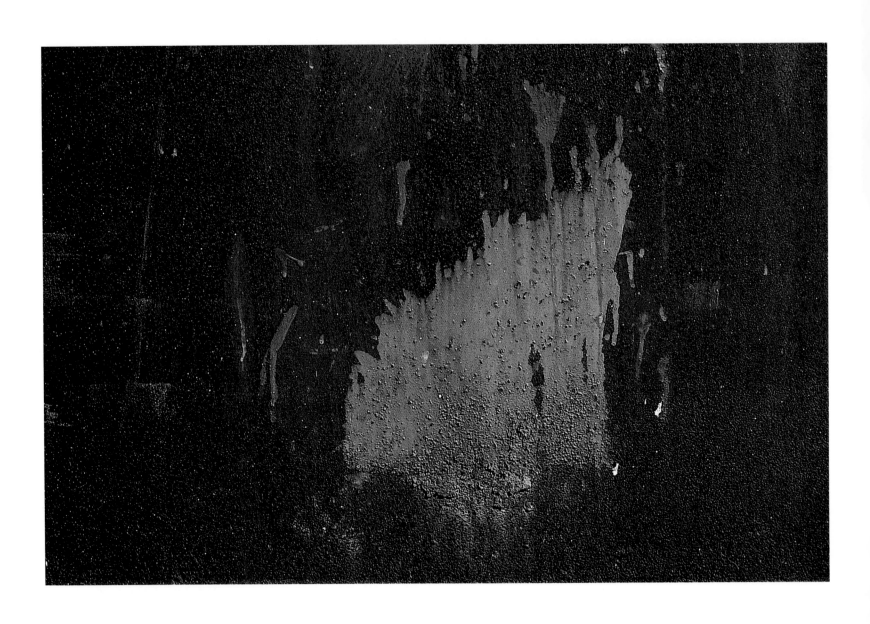

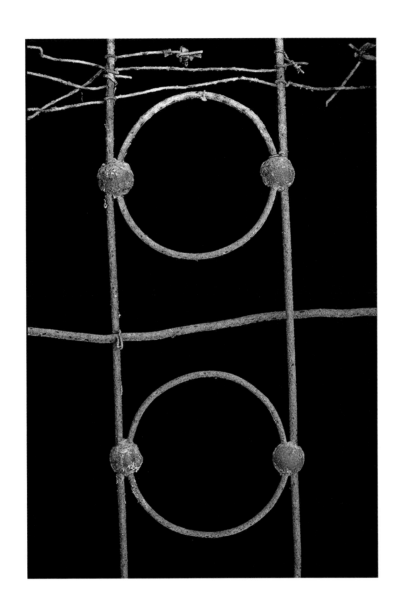

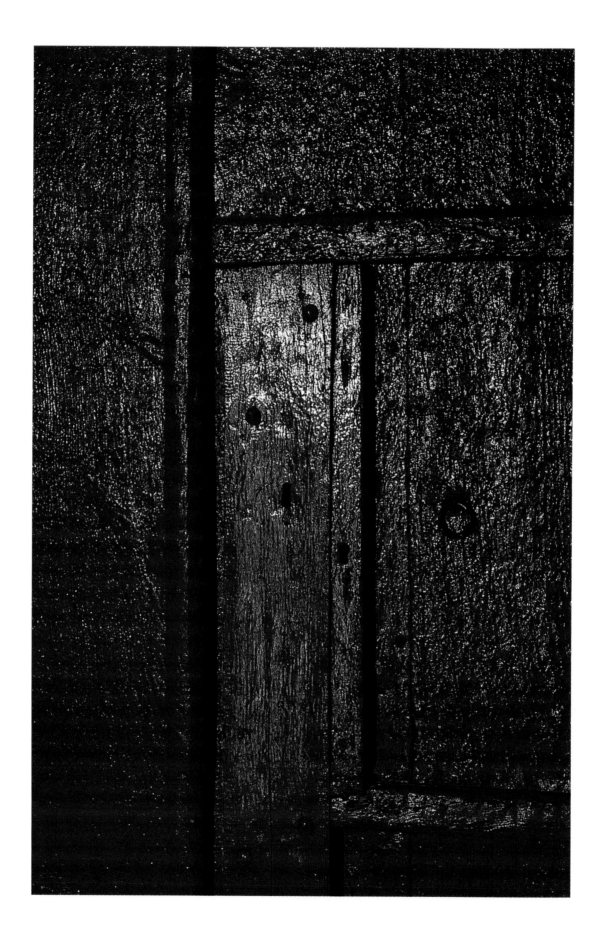

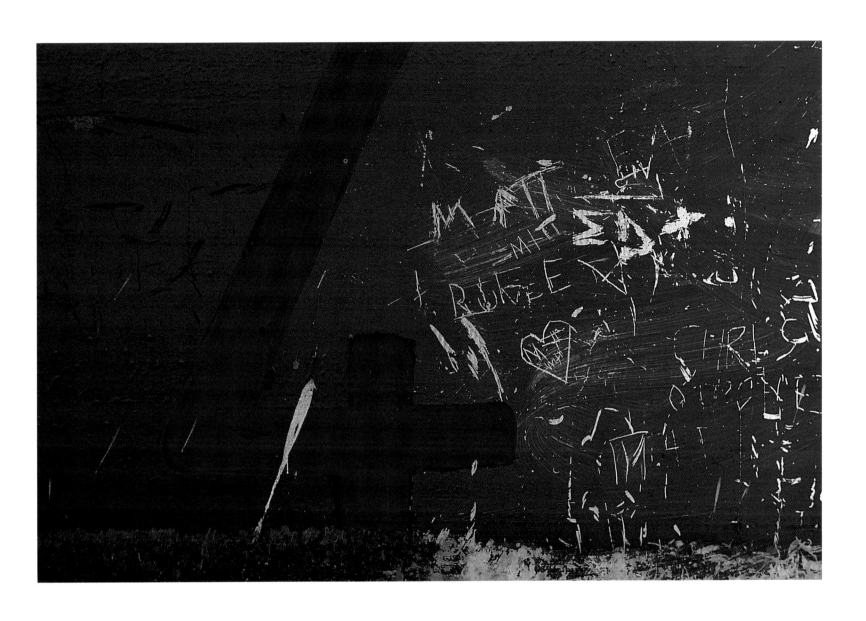

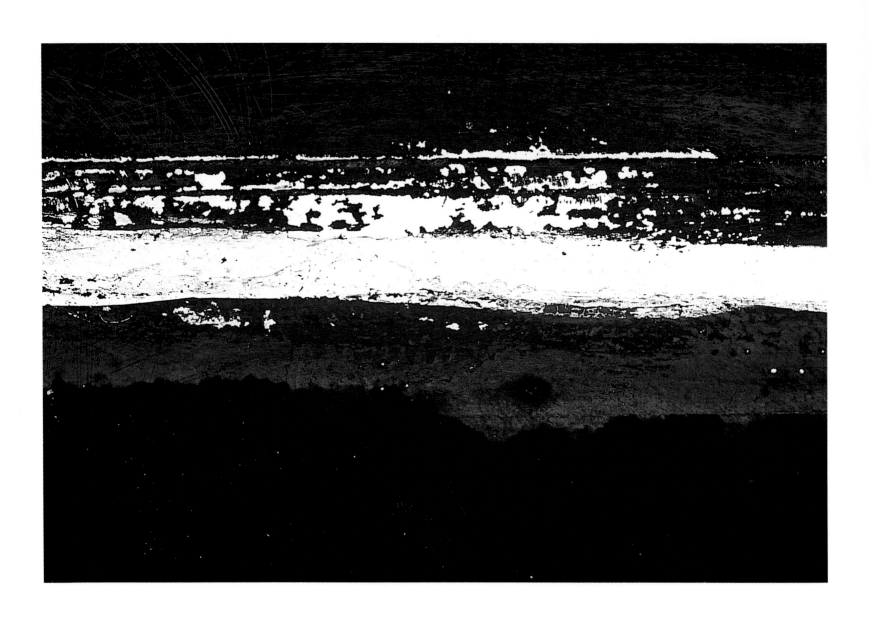

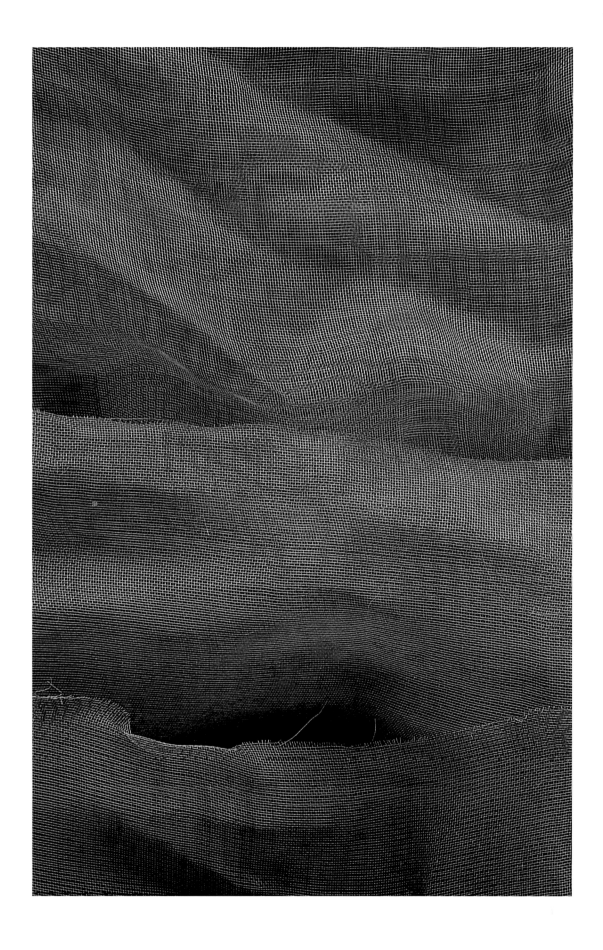

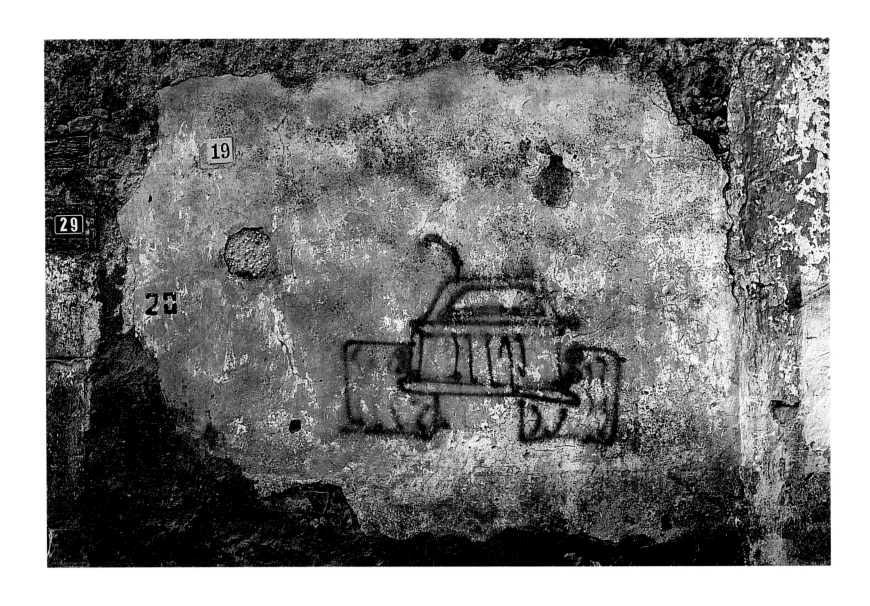

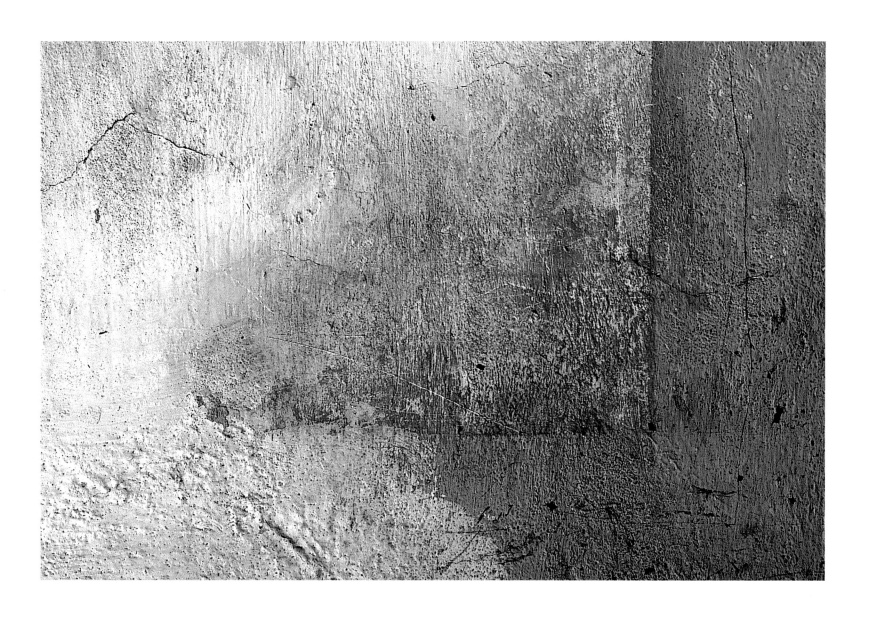

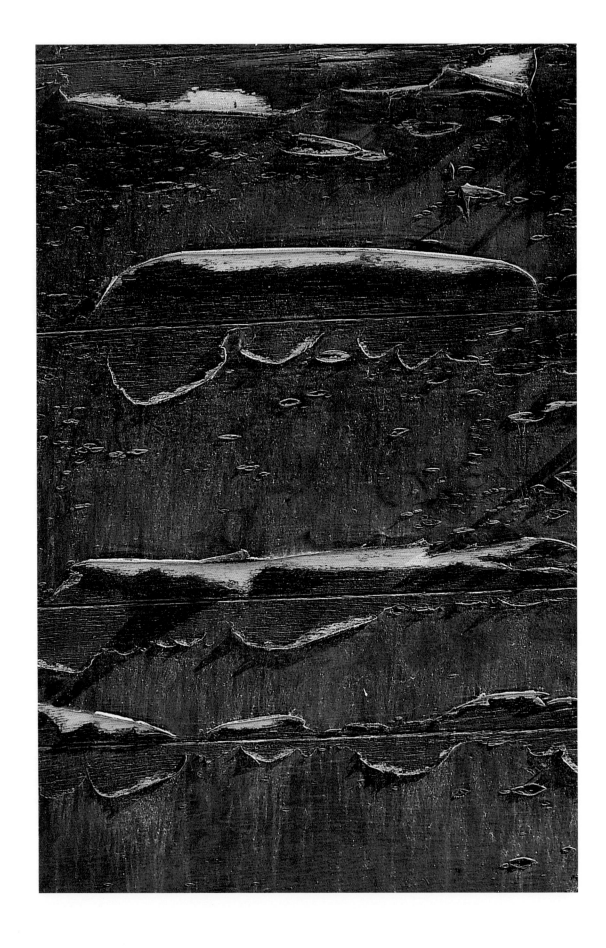

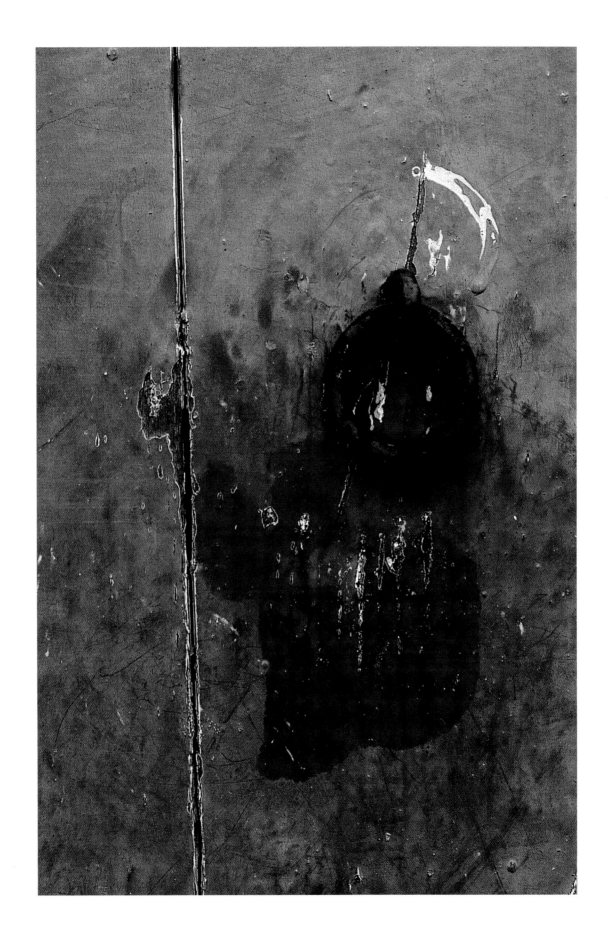

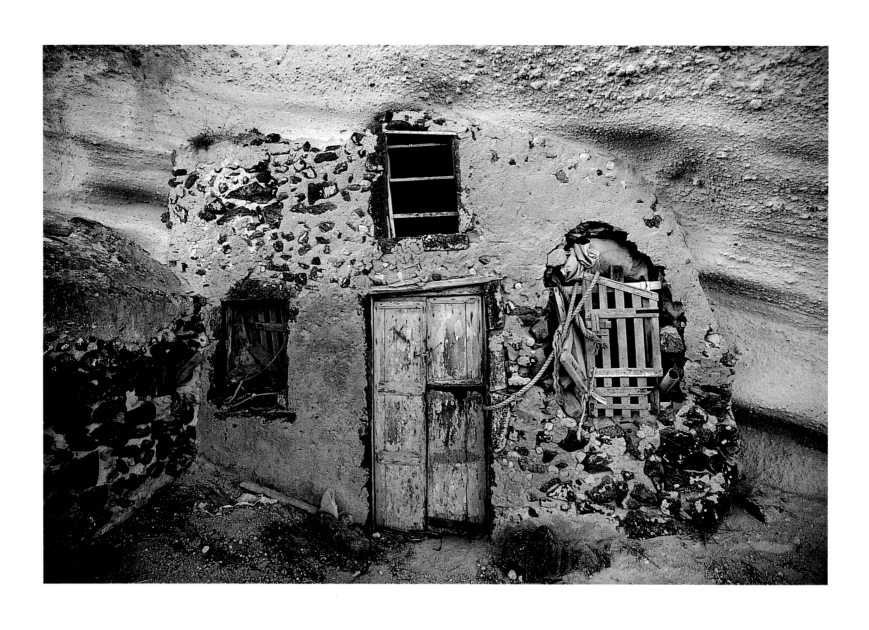

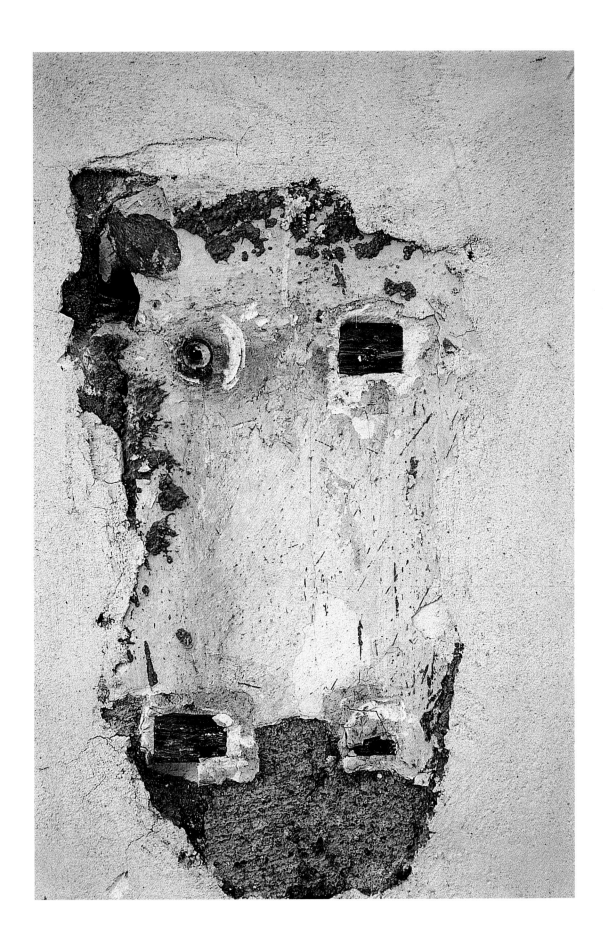

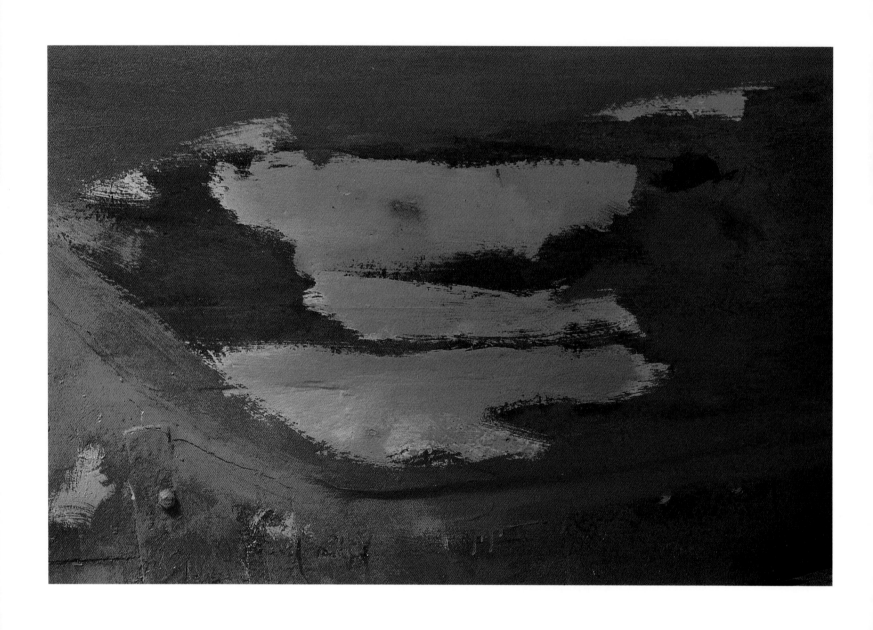

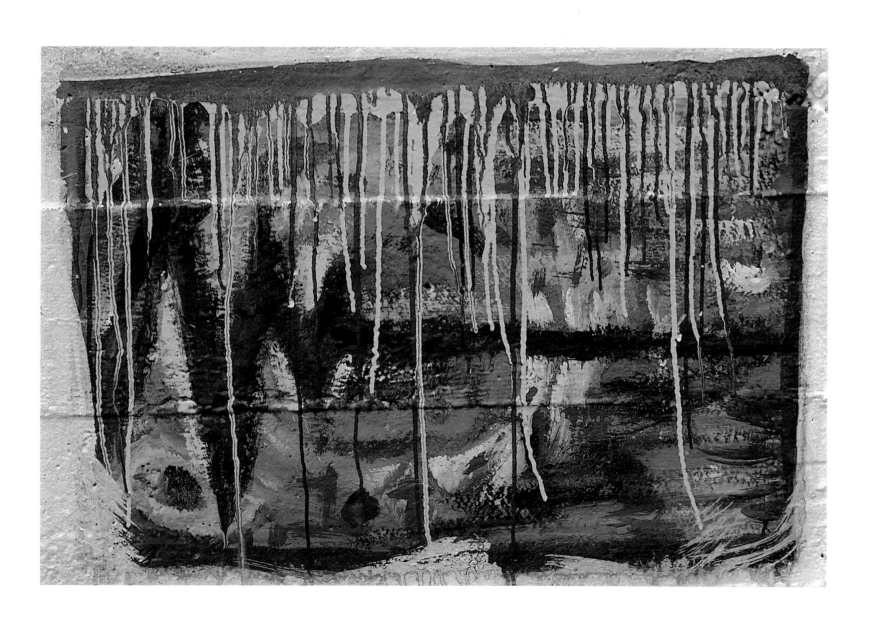

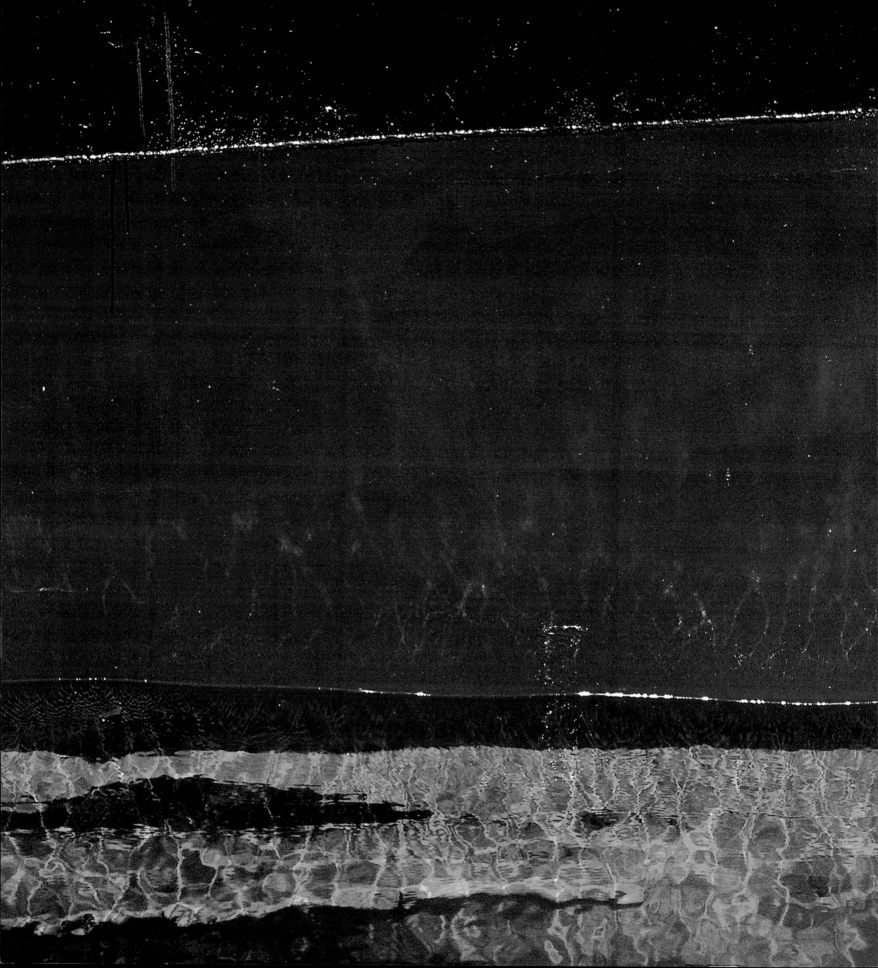

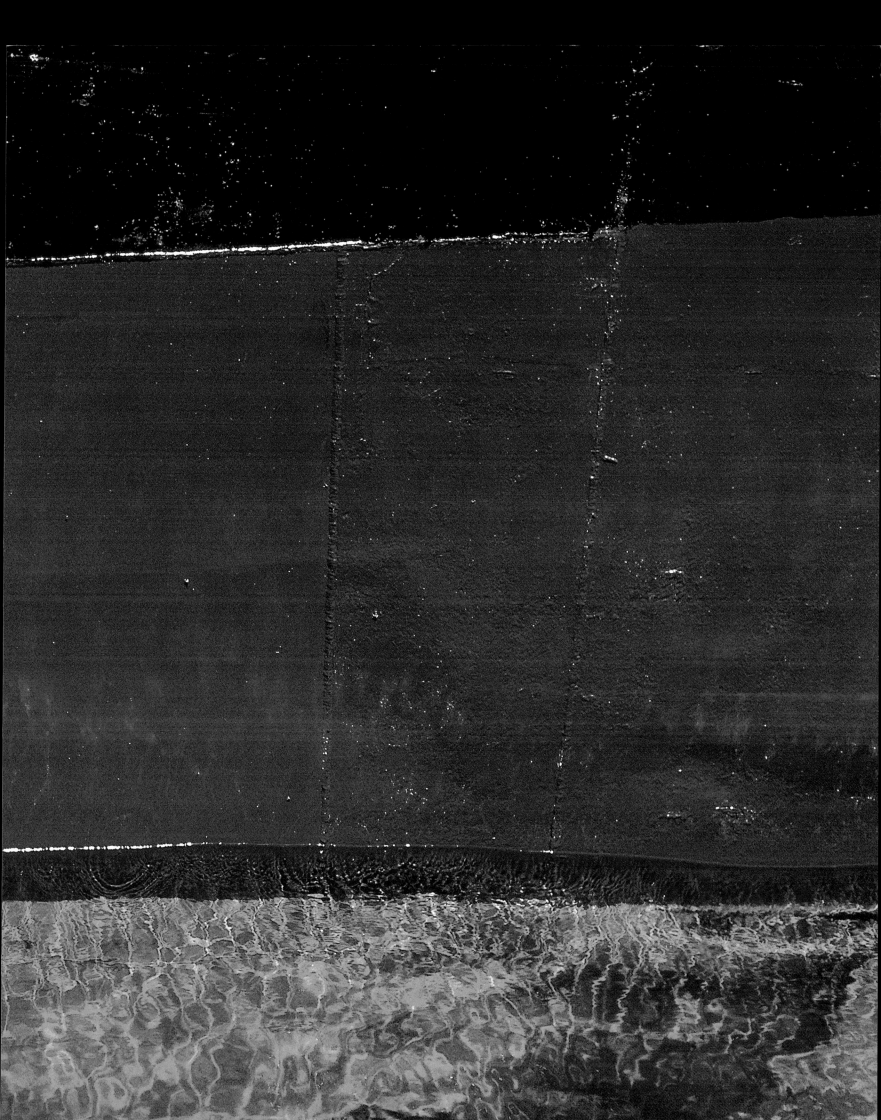

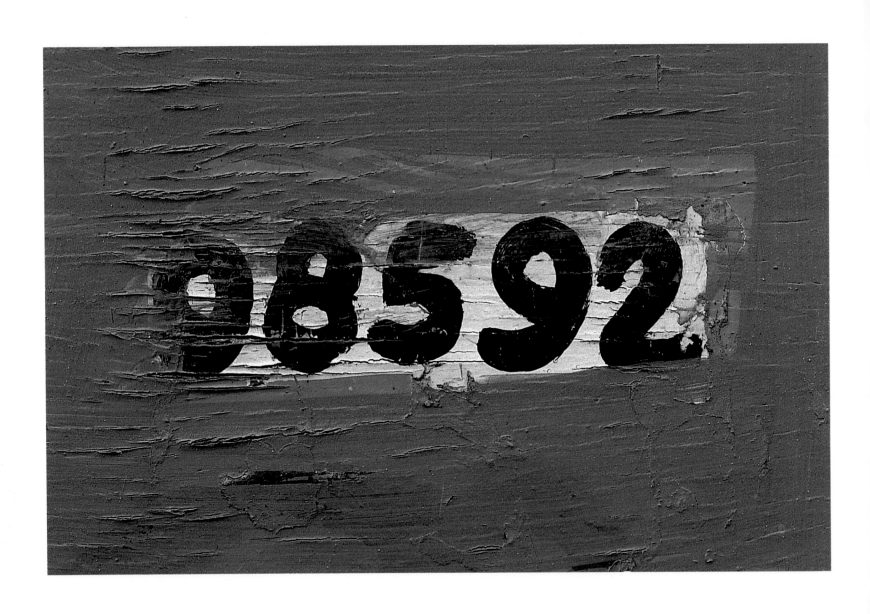

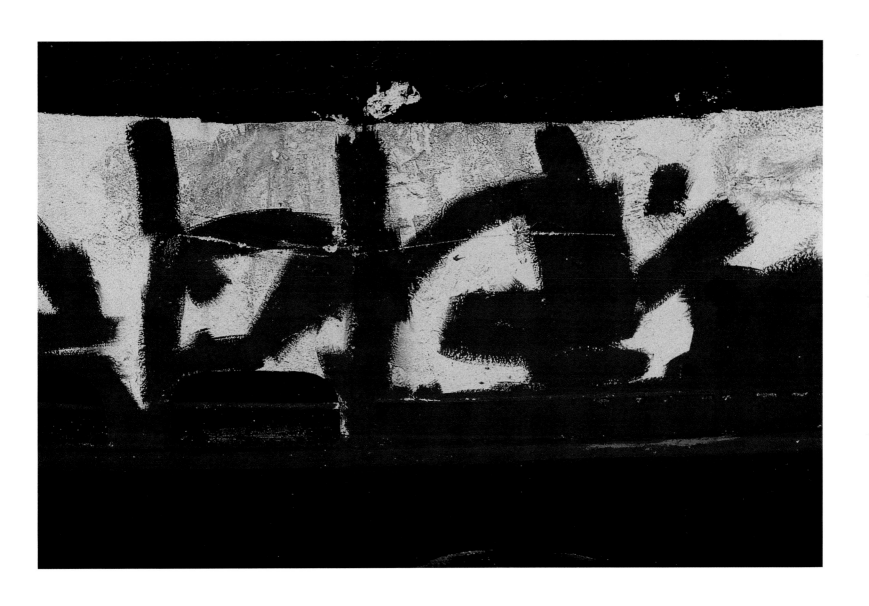

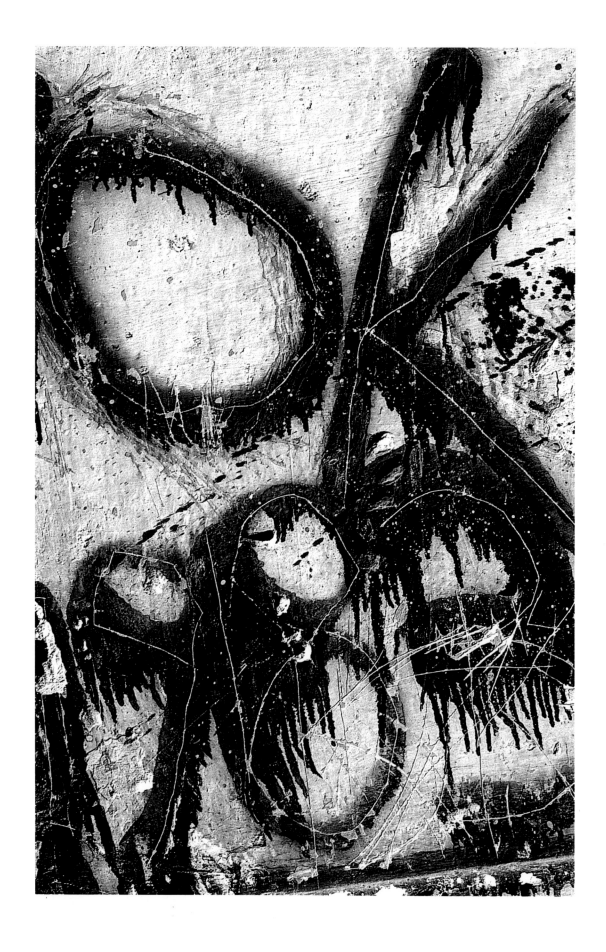

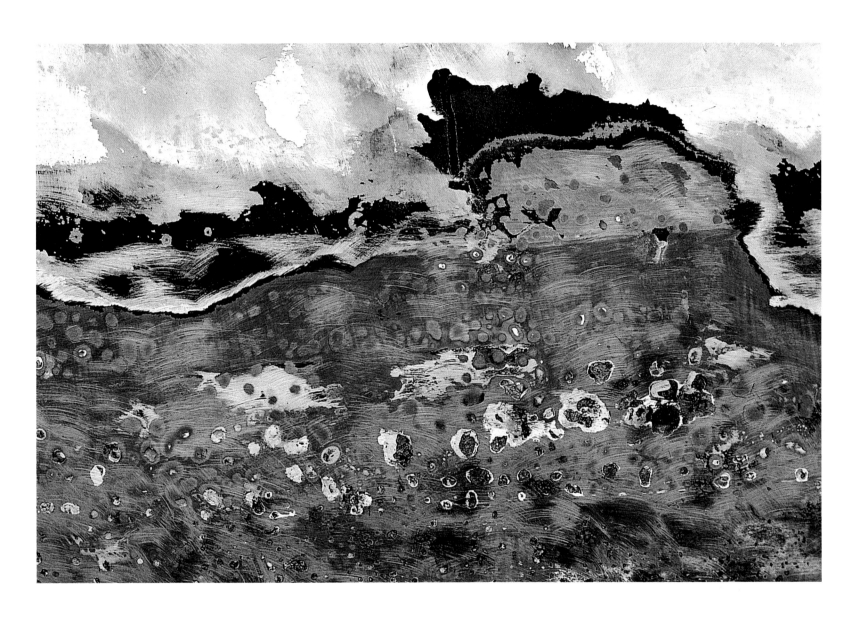

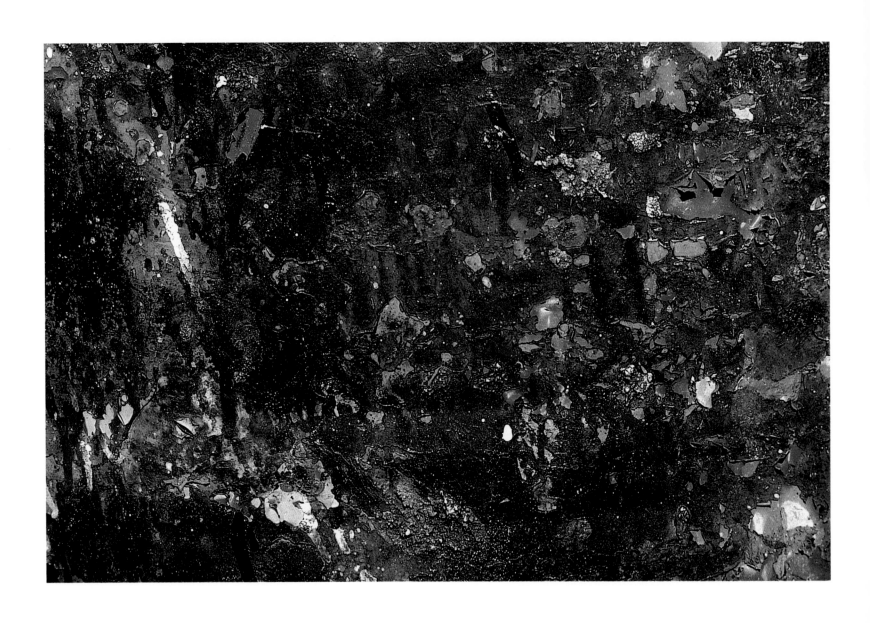

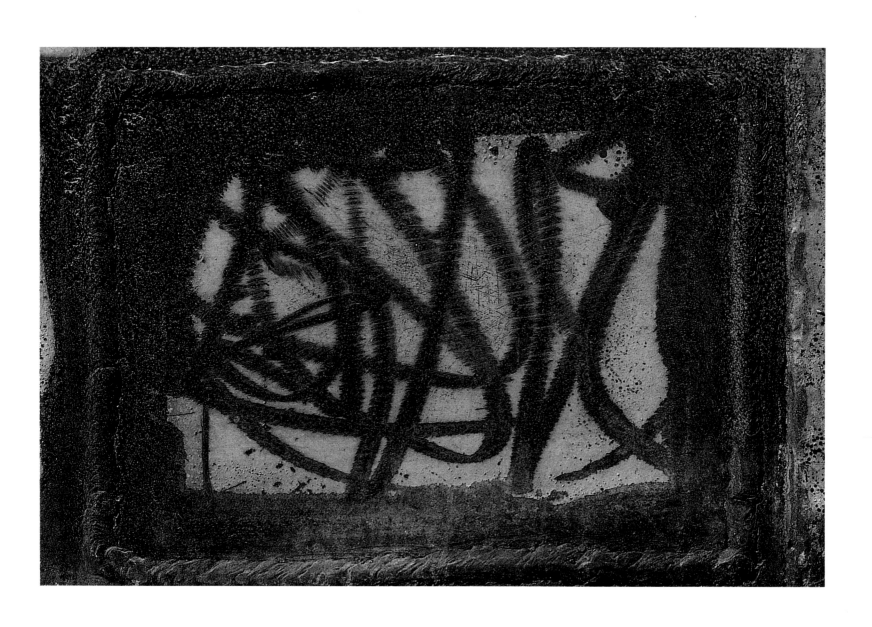

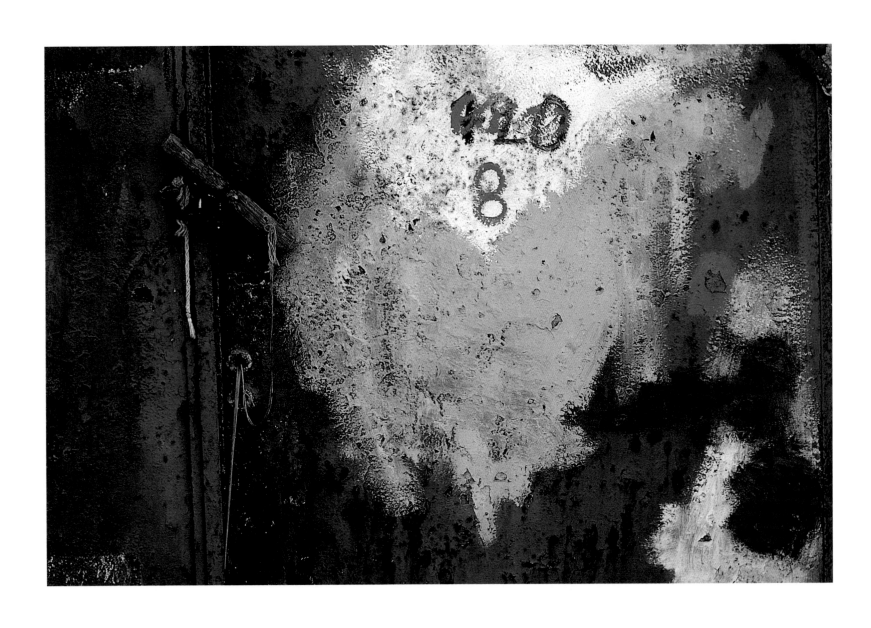

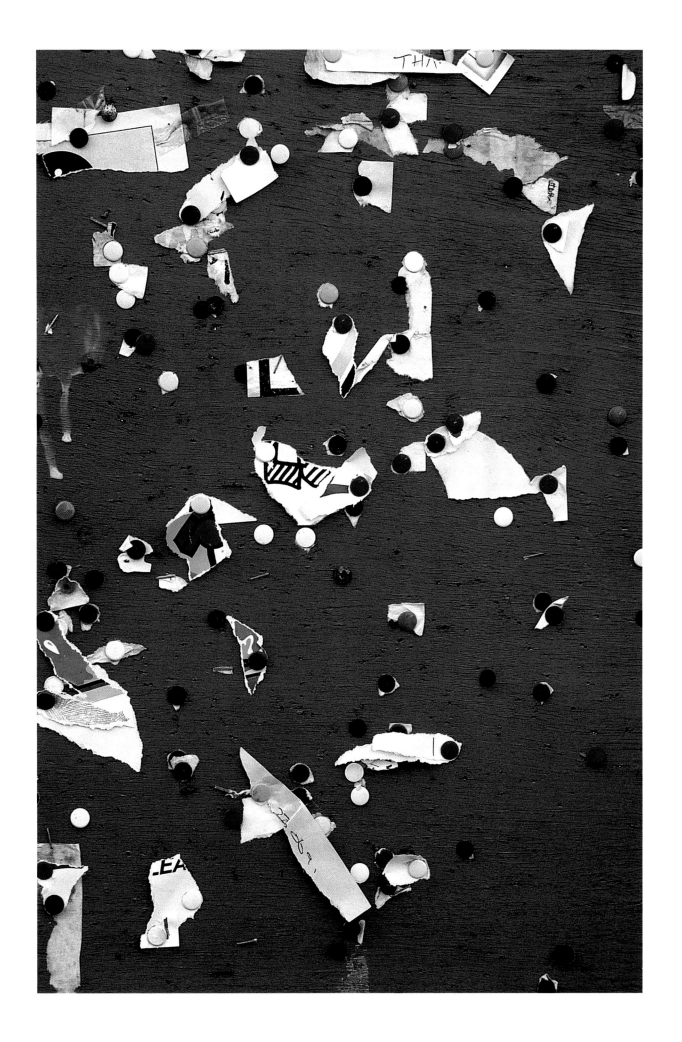

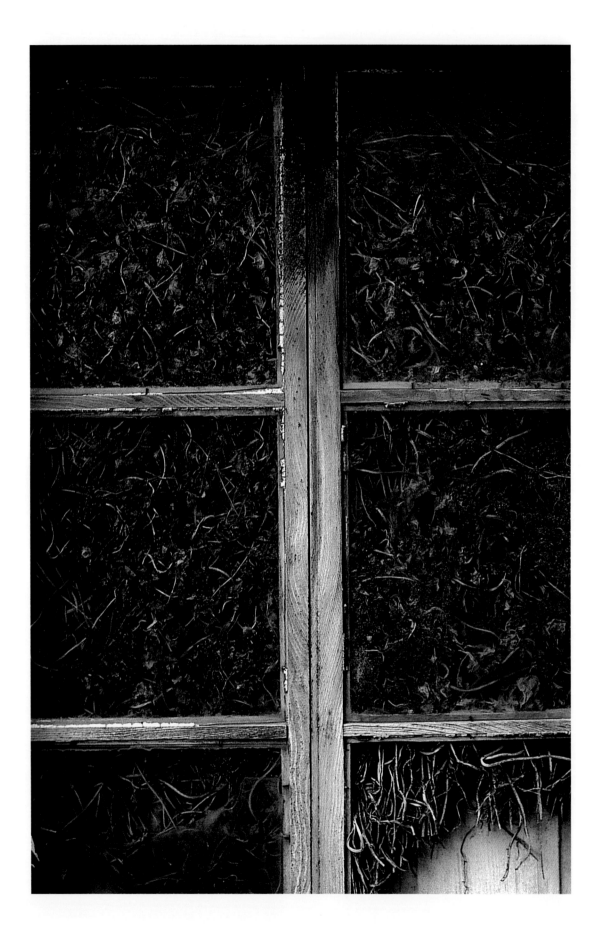

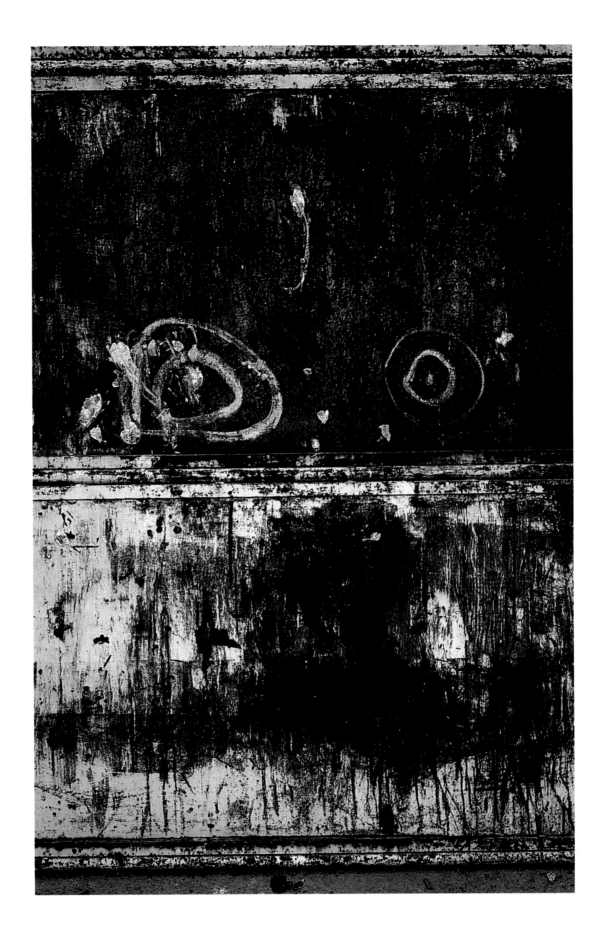

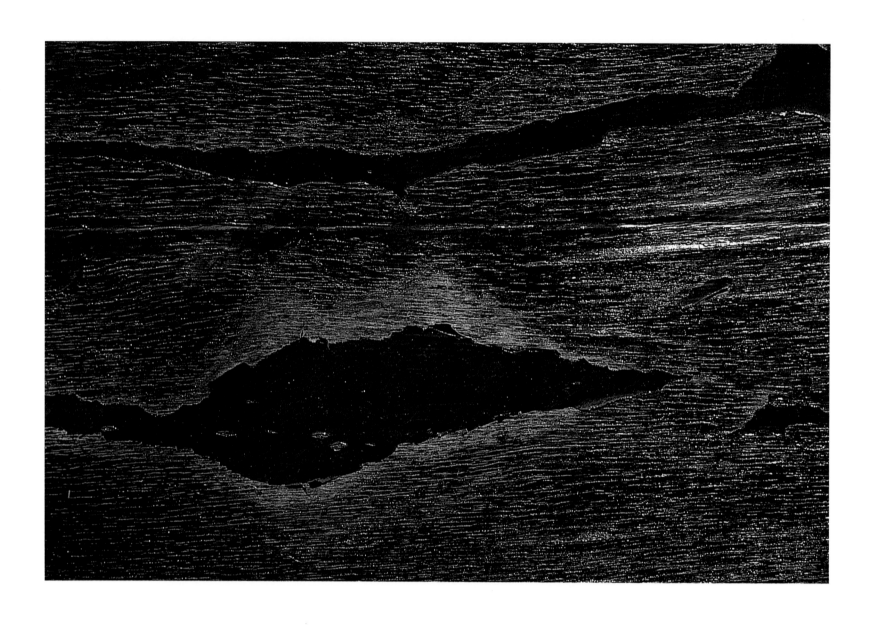

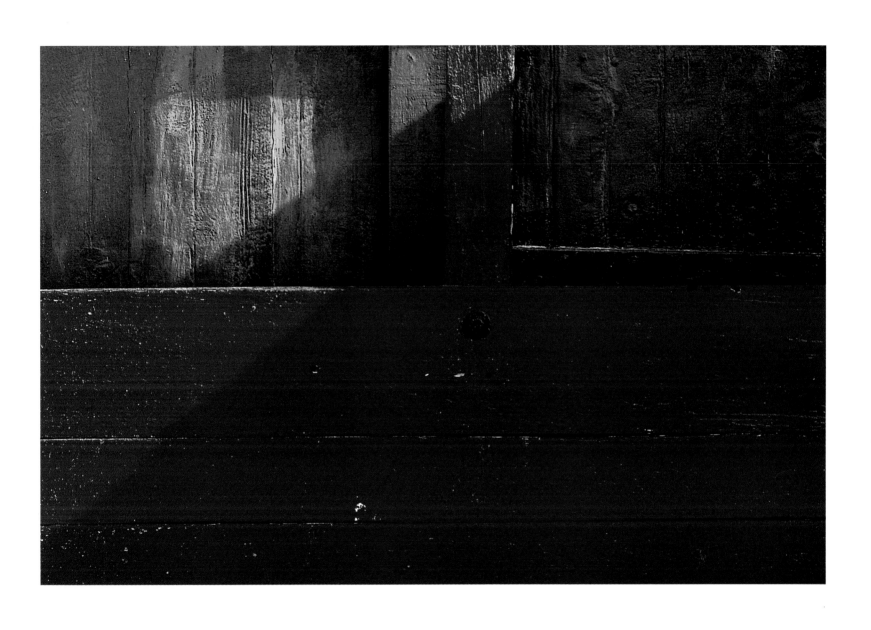

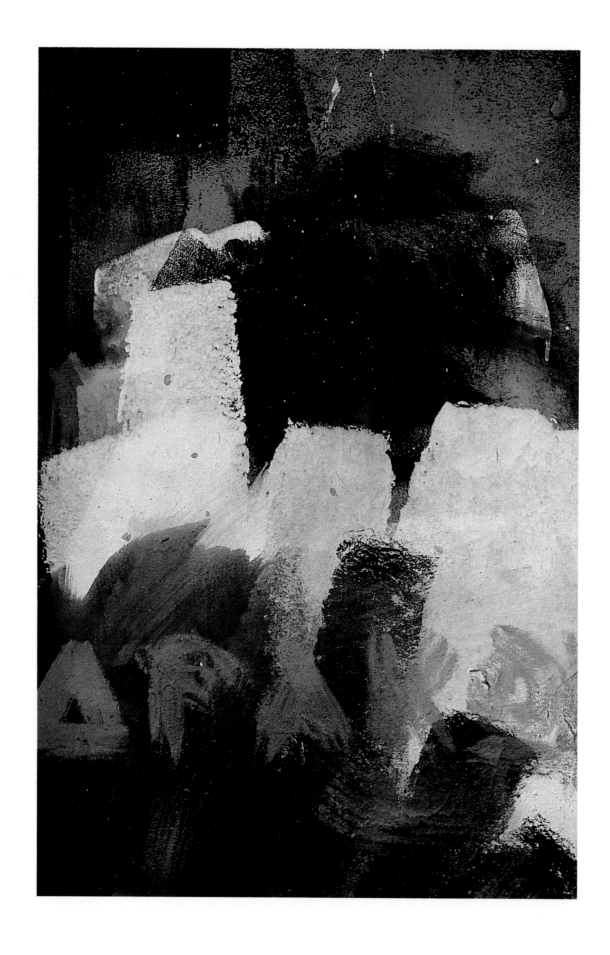

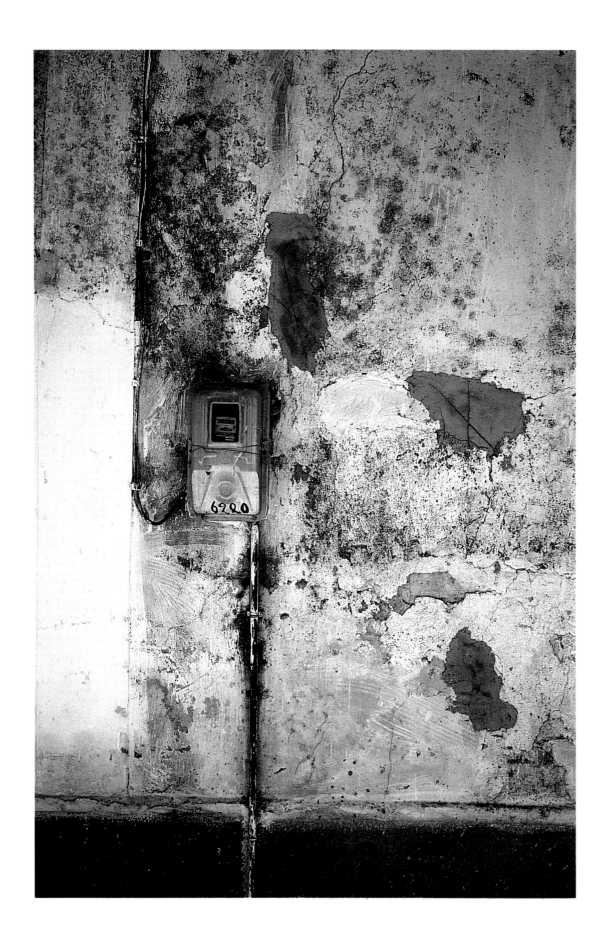

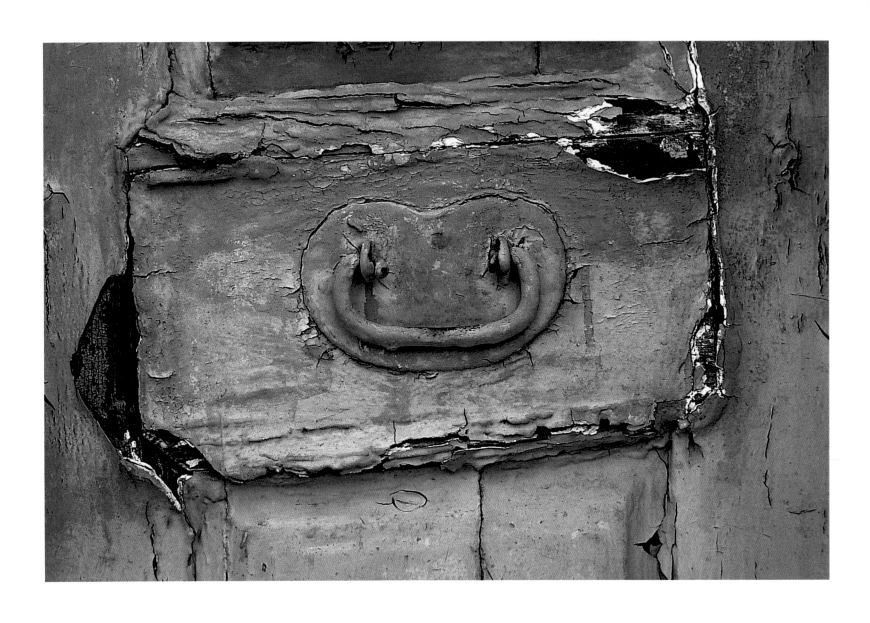

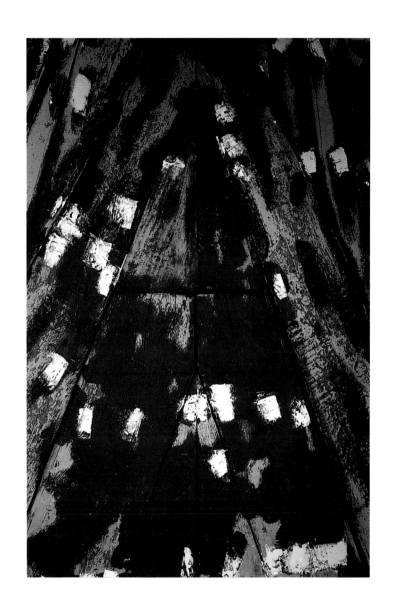

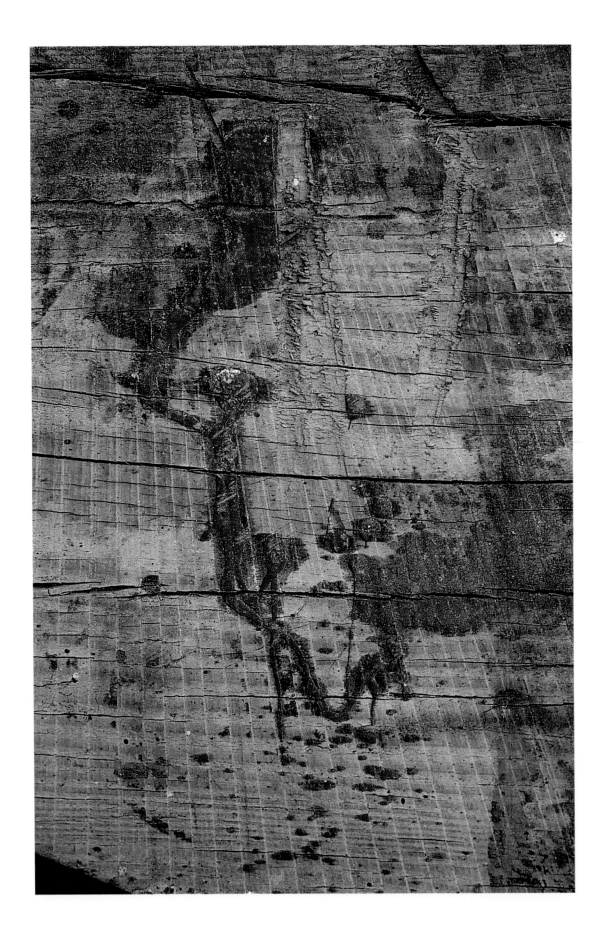

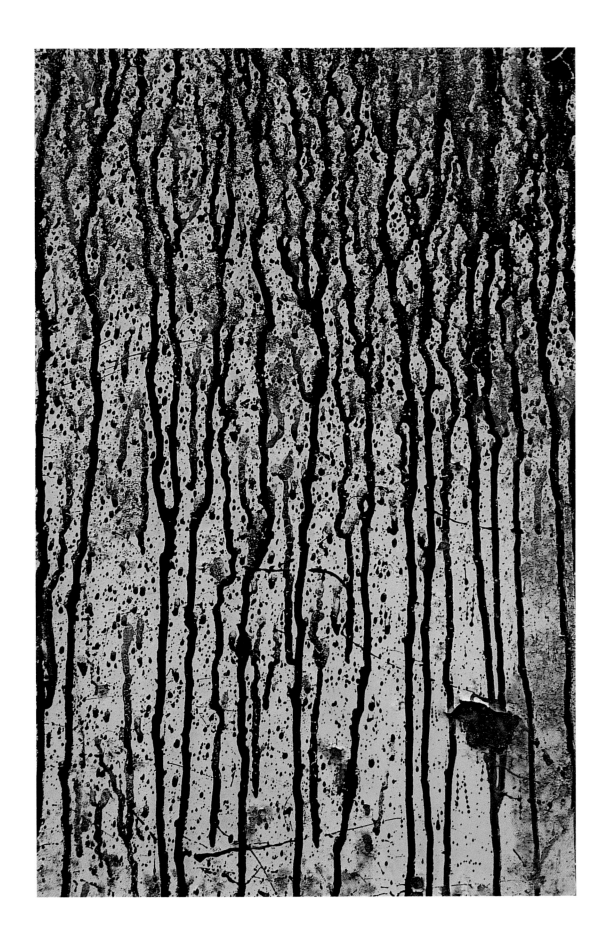

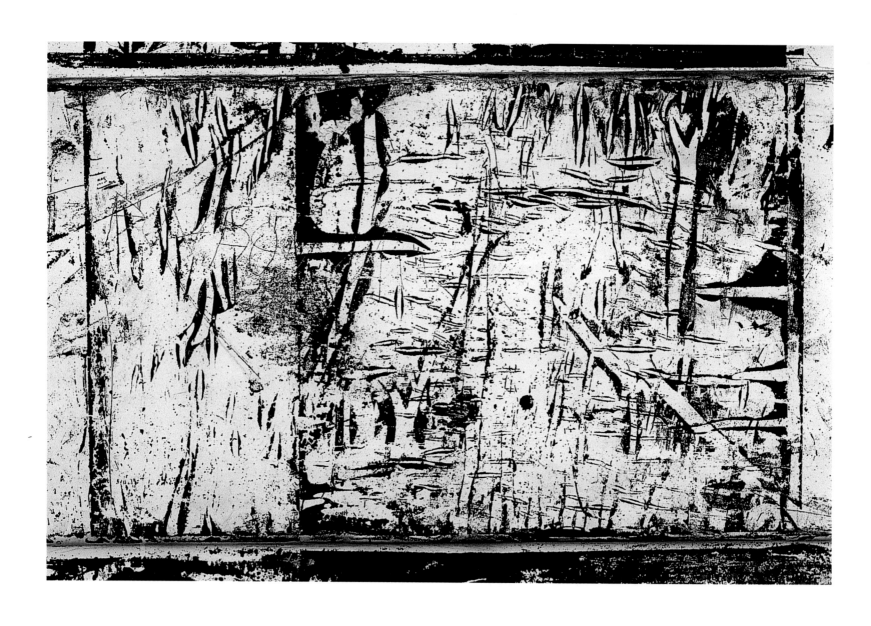

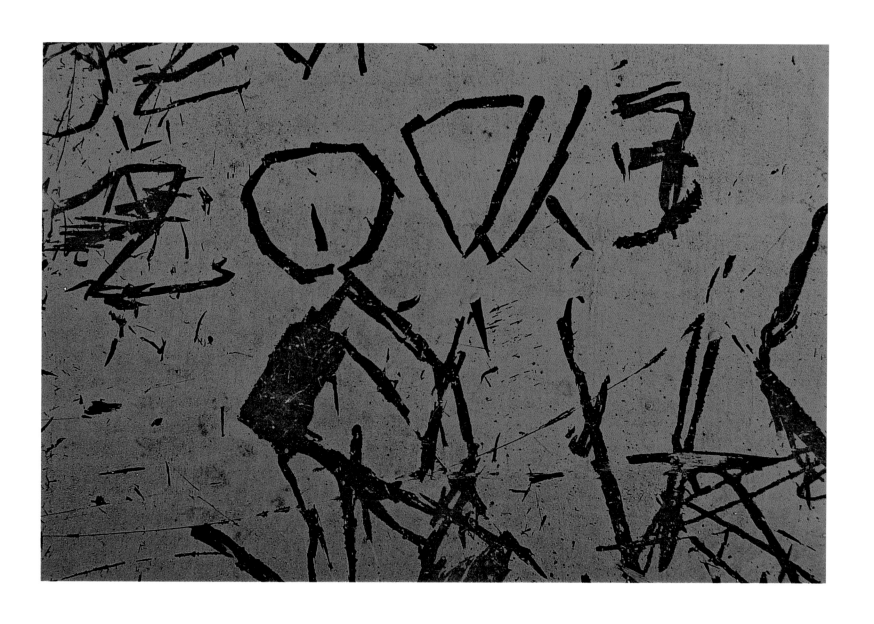

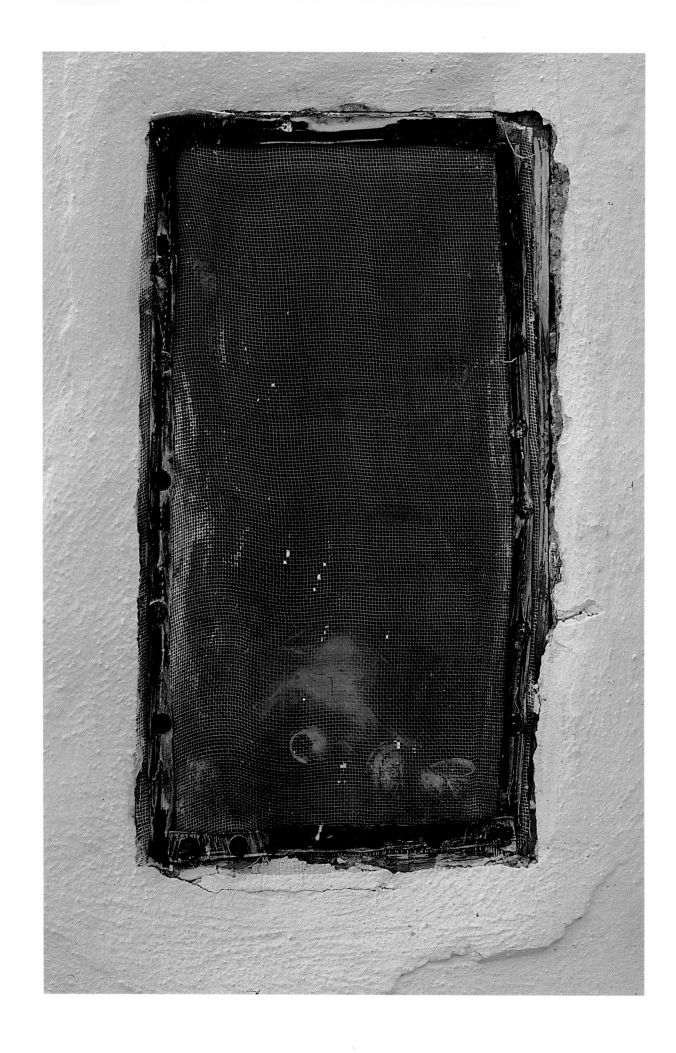

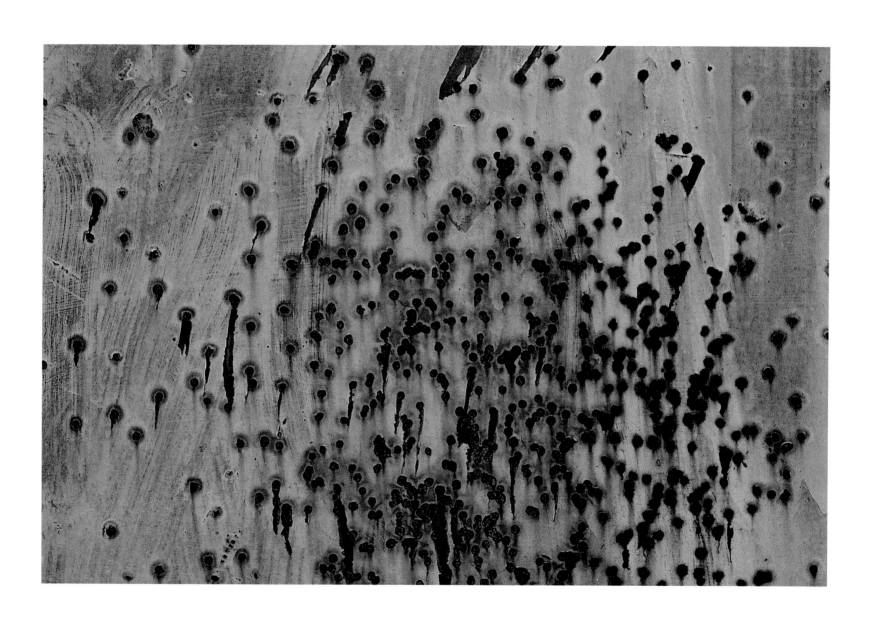

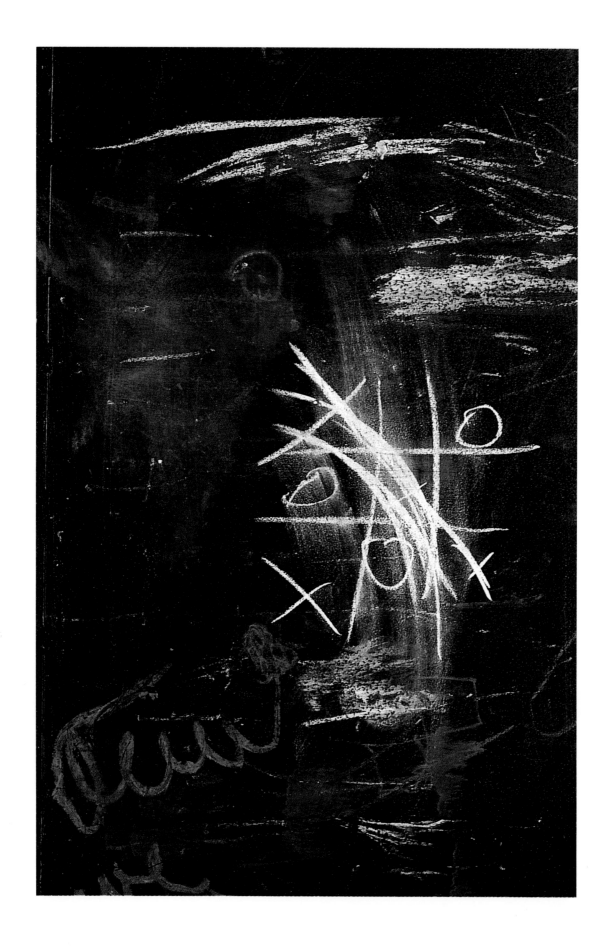

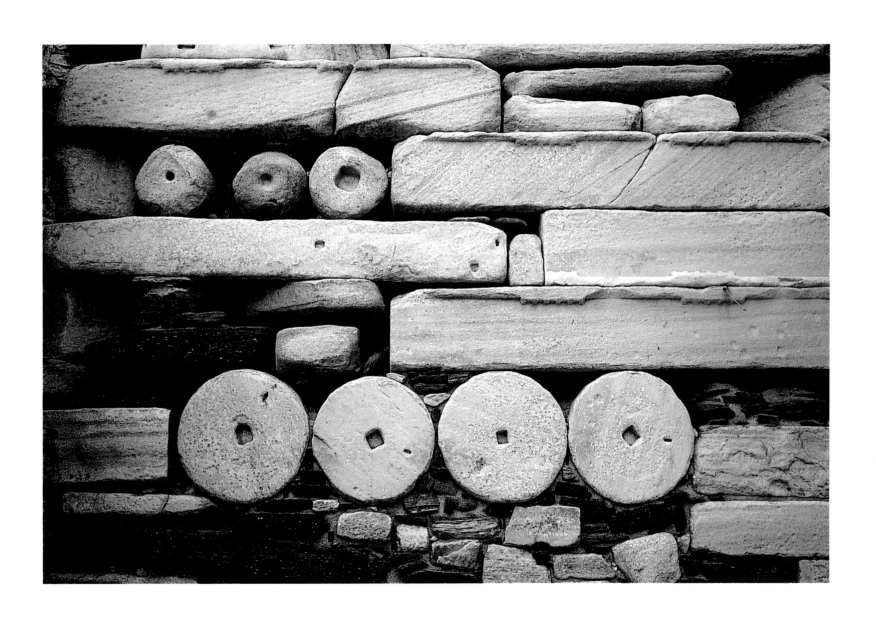

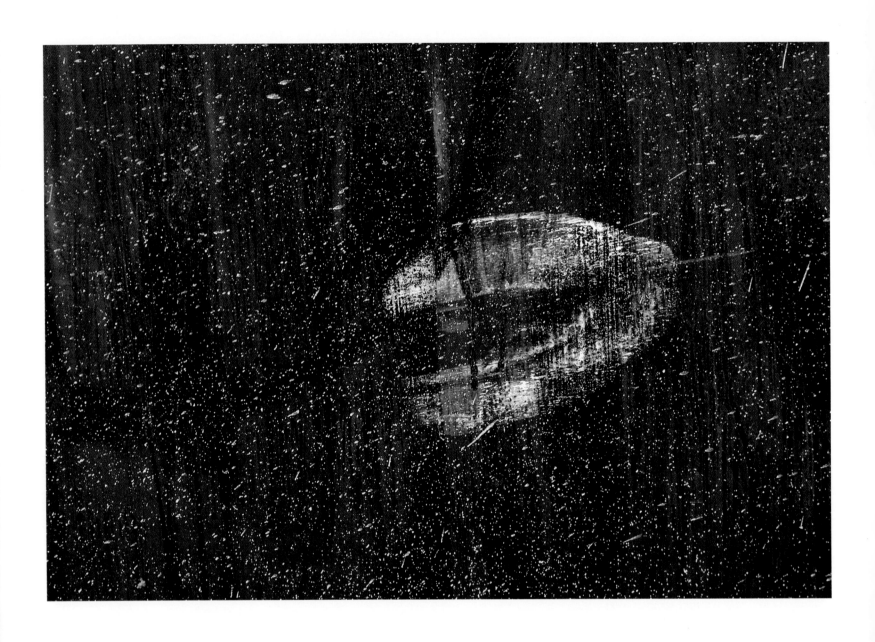

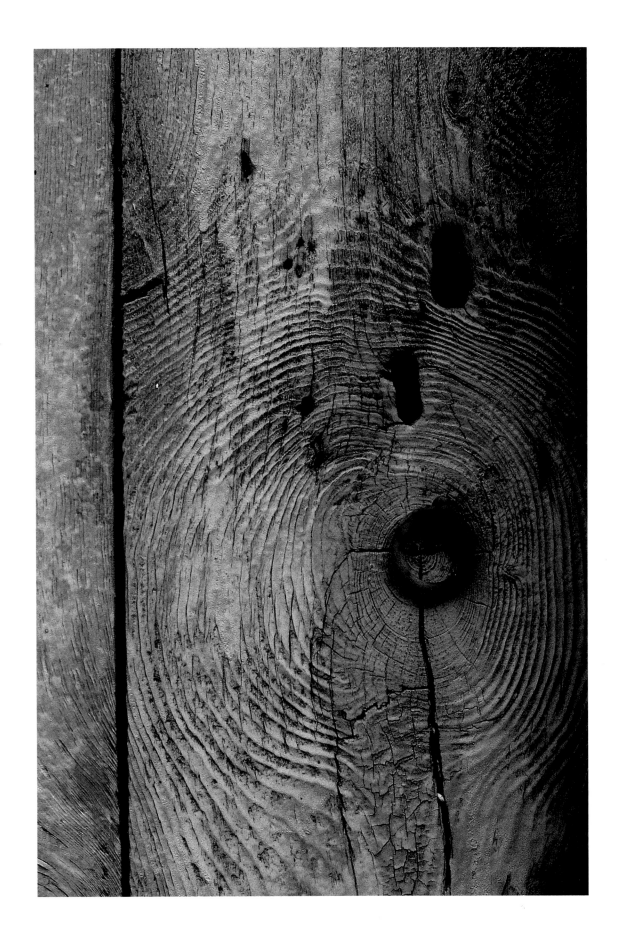

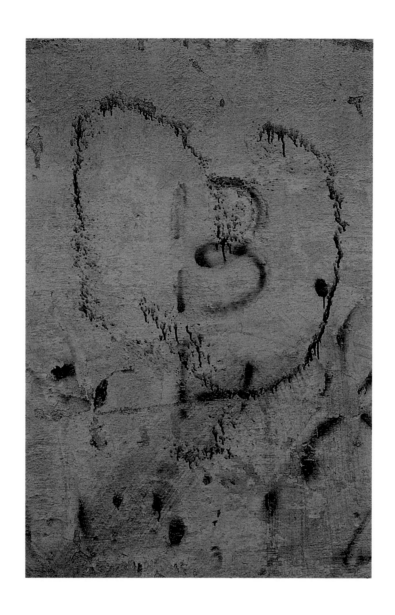

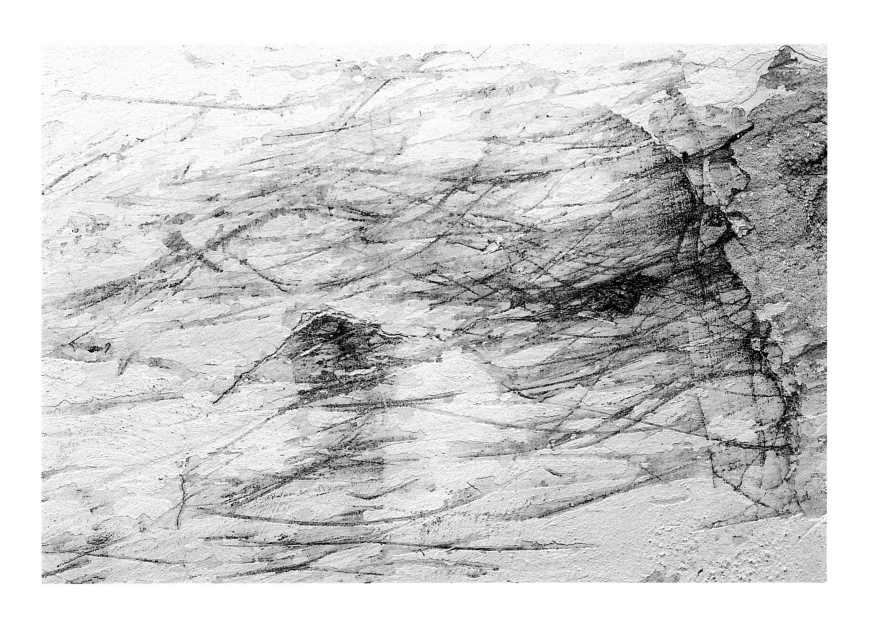

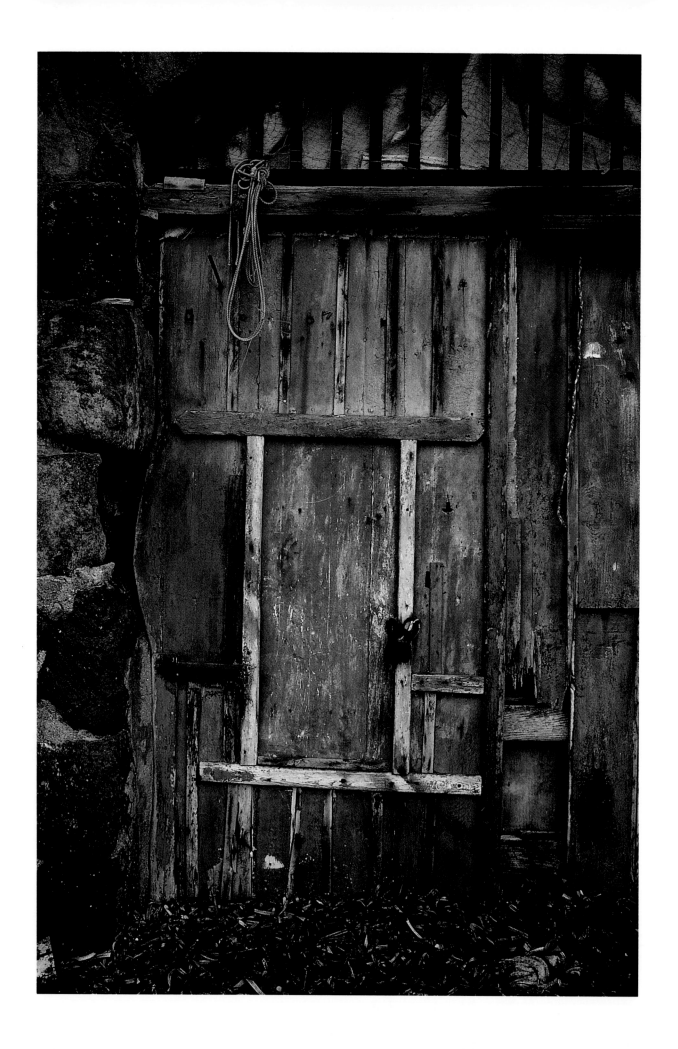

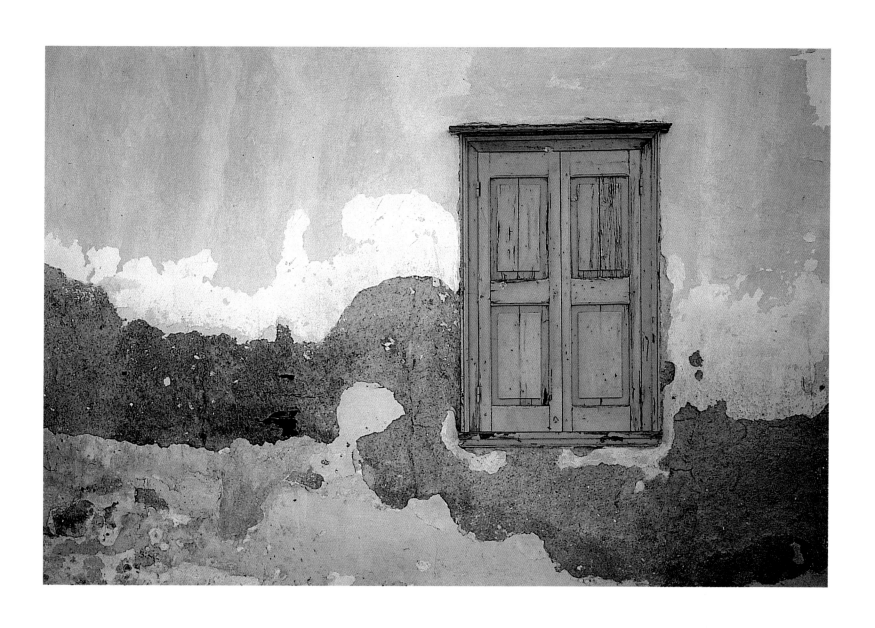

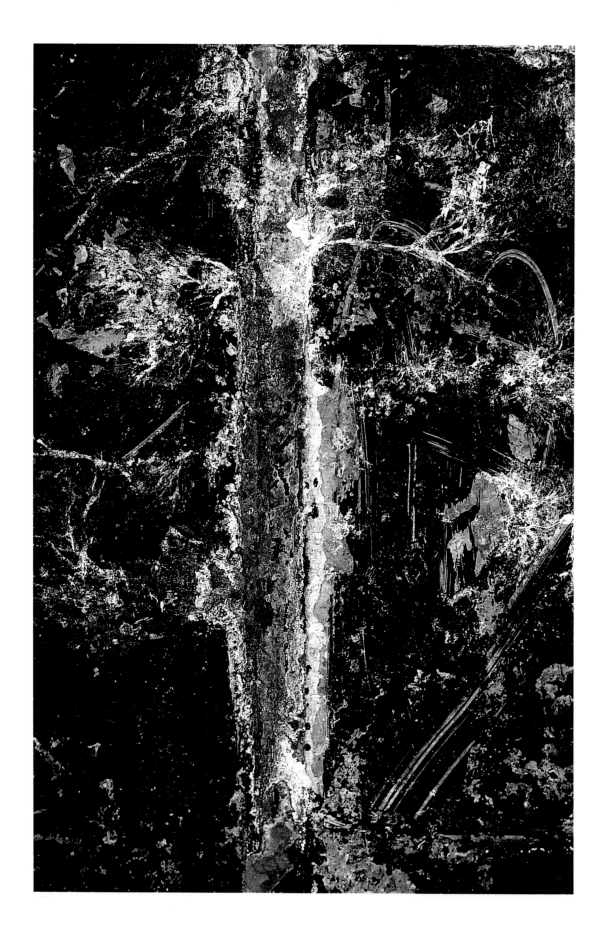

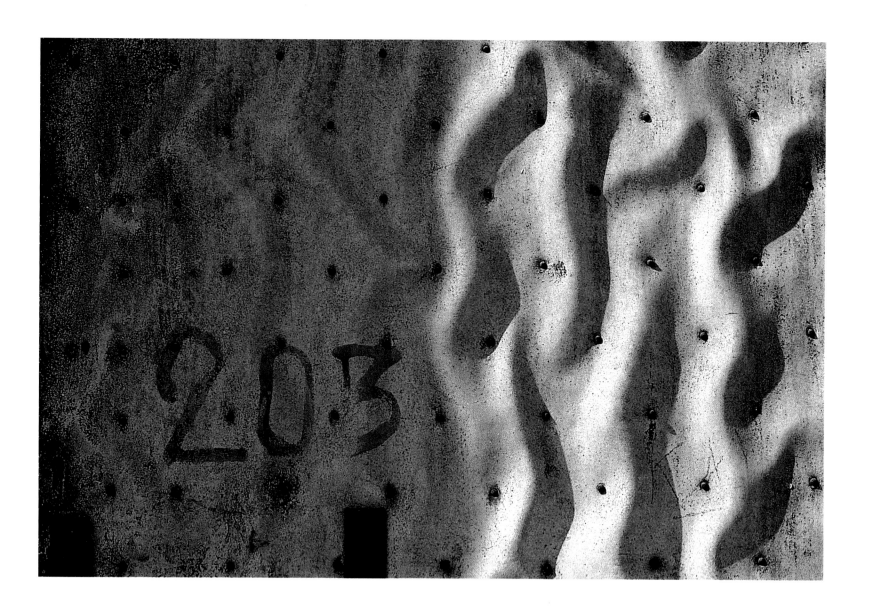

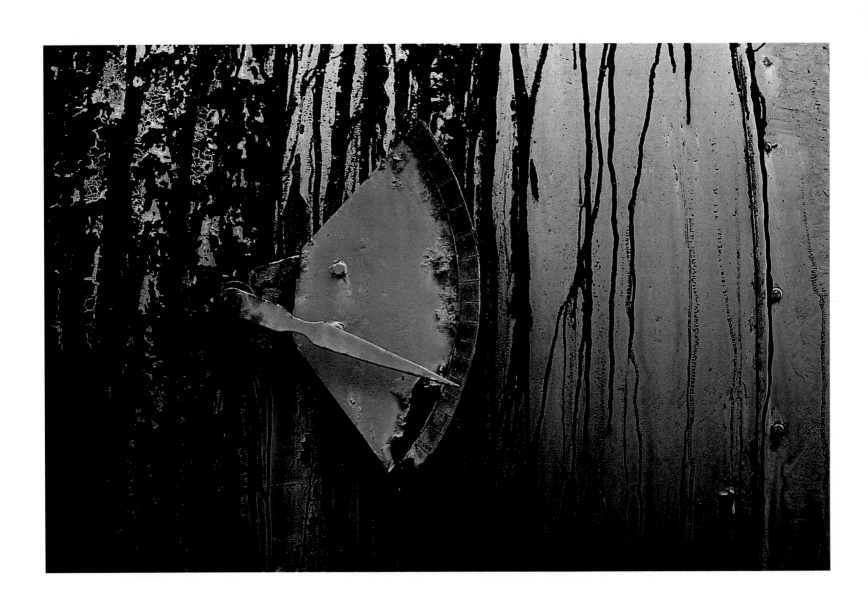

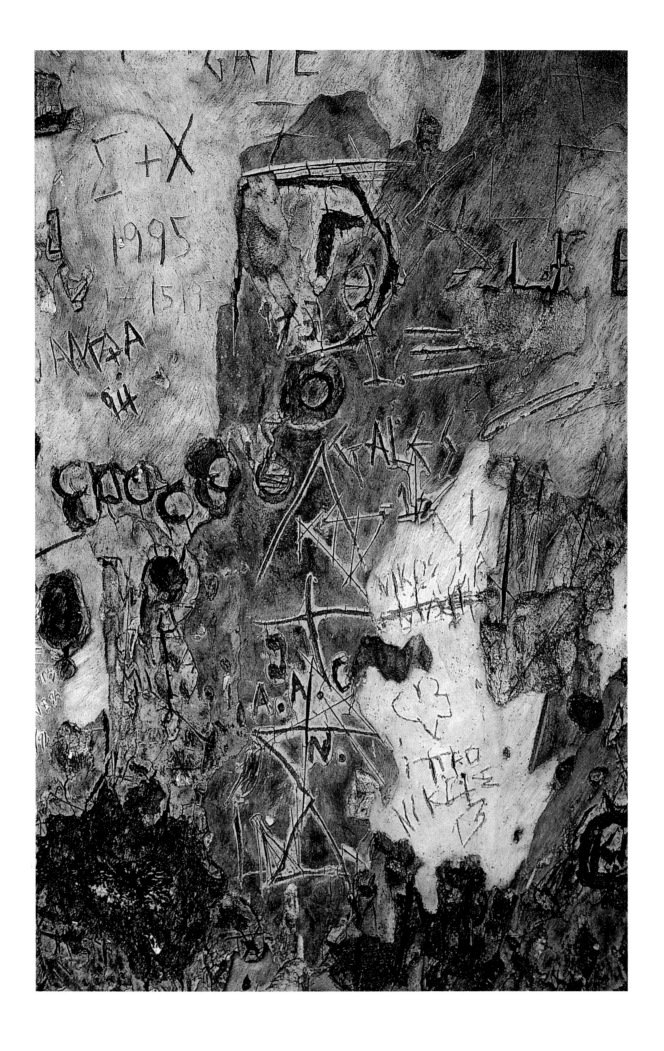

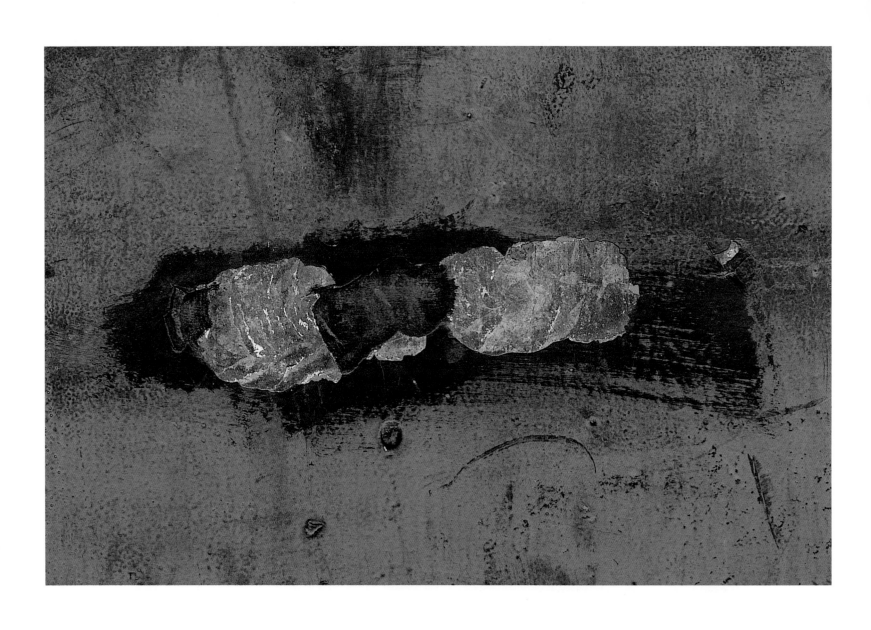

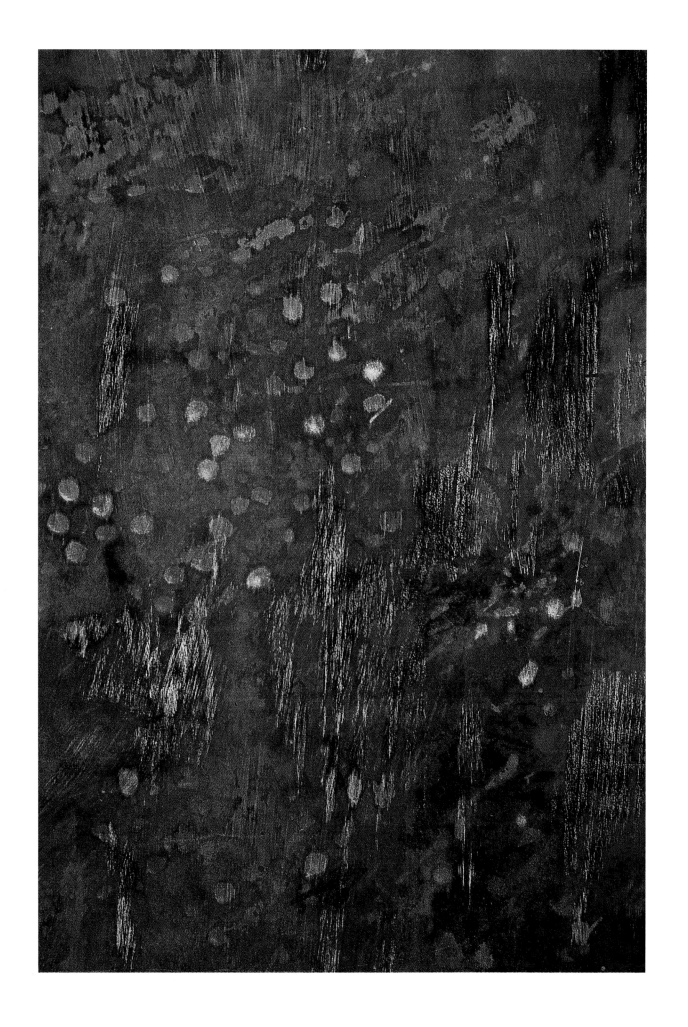

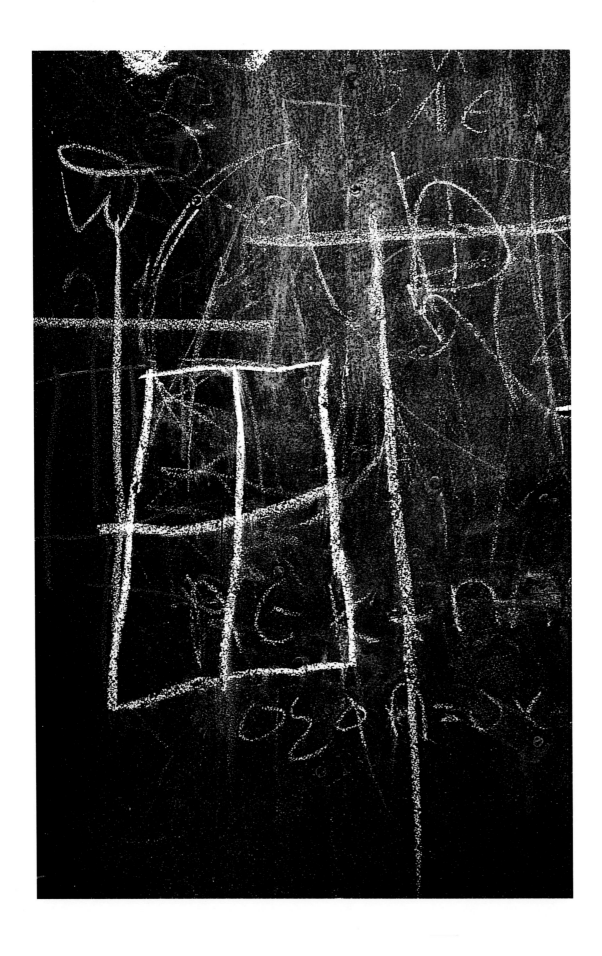

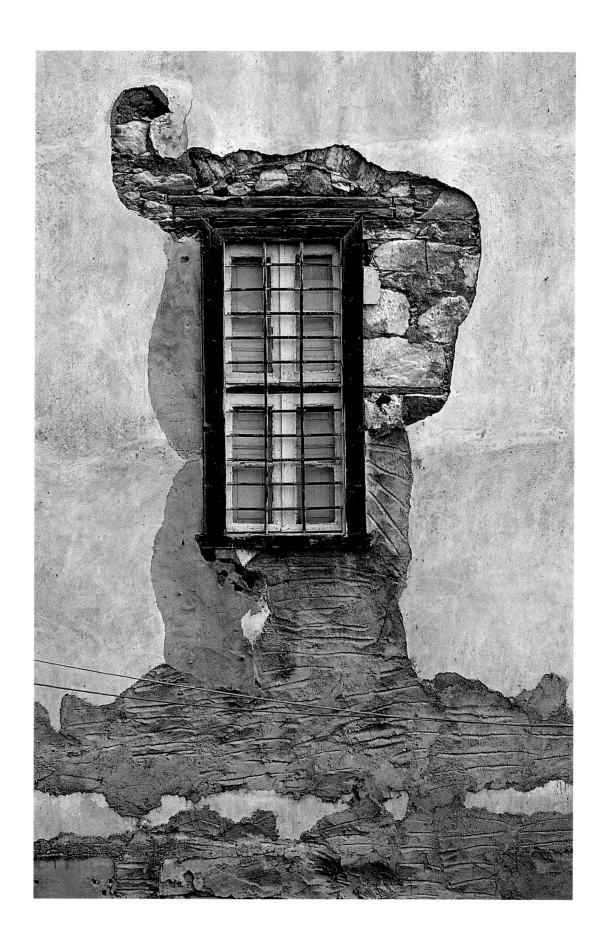

117

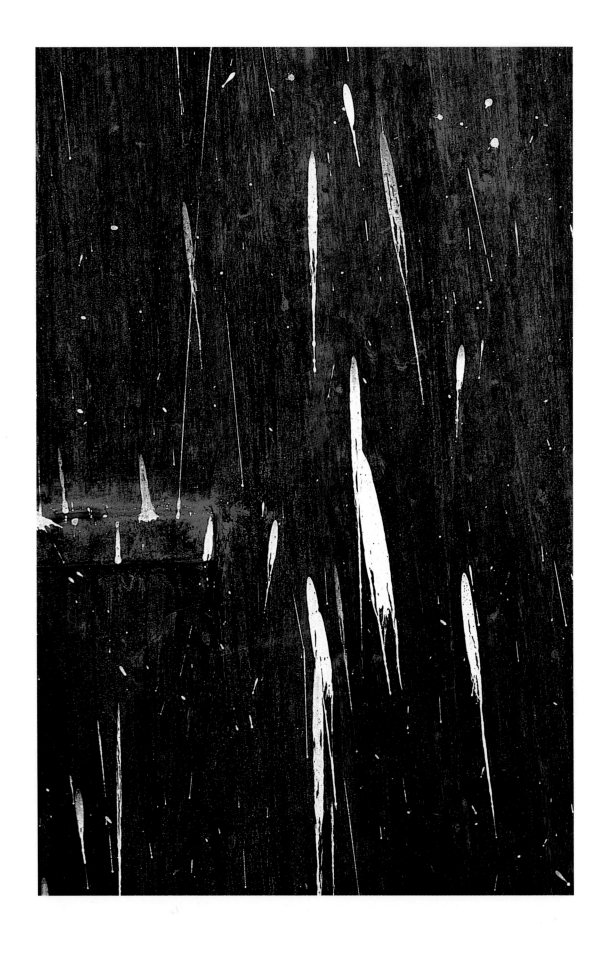

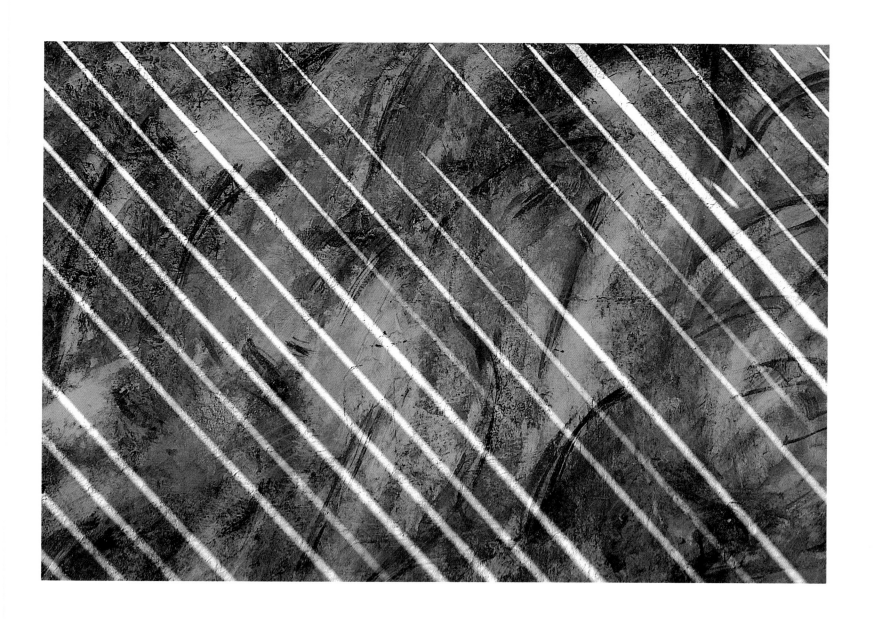

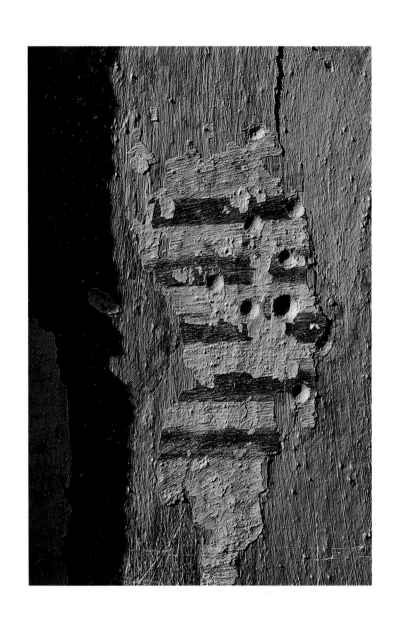

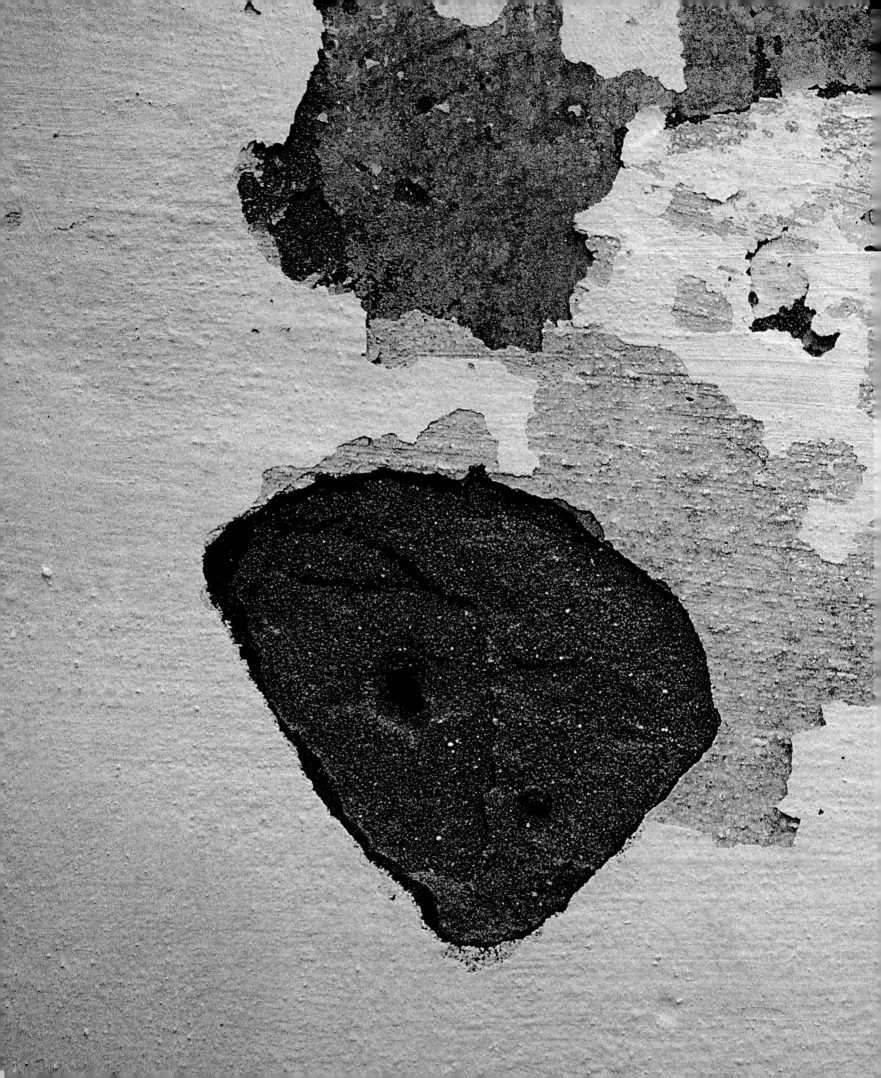